PAINTING *four seasons* OF FABULOUS FLOWERS

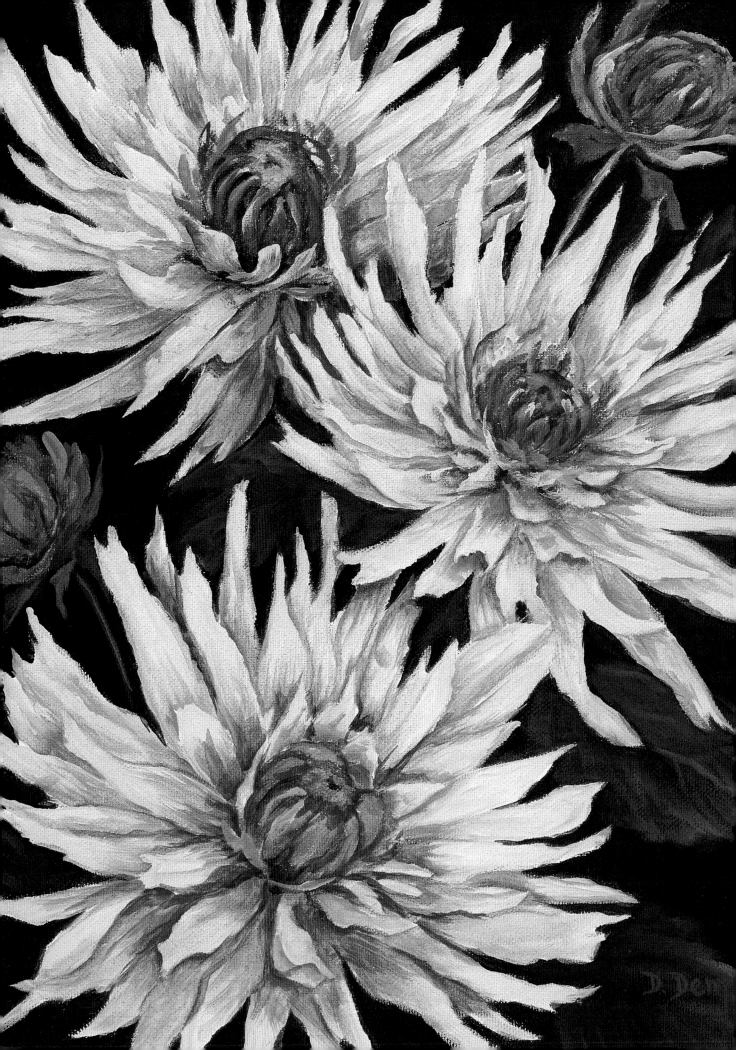

PAINTING *four seasons* OF FABULOUS FLOWERS

dorothy dent

NORTH LIGHT BOOKS

CINCINNATI, OHIO
www.artistsnetwork.com

Painting Four Seasons of Fabulous Flowers.
Copyright © 2005 by Dorothy Dent. Manufactured in China. All rights reserved. The patterns and drawings in this book are for the personal use of the decorative painter. By permission of the author and publisher, they may be either hand-traced or photocopied to make single copies, but under no circumstances may they be resold or republished. It is permissible for the purchaser to paint the designs contained herein and sell them at fairs, bazaars and craft shows. No other part of this book may be reproduced in any form or by any electronic or mechanical means including information storage and retrieval systems without permission in writing from the publisher, except by a reviewer, who may quote brief passages in a review. The content of this book has been thoroughly reviewed for accuracy. However, the author and publisher disclaim any liability for any damages, losses or injuries that may result from the use or misuse of any product or information presented herein. It is the purchaser's responsibility to read and follow all instructions and warnings on all product labels. Published by North Light Books, an imprint of F+W Publications, Inc., 4700 East Galbraith Road, Cincinnati, Ohio 45236. (800) 289-0963. First edition.

Other fine North Light Books are available from your local bookstore, art supply store or direct from the publisher.

09 08 07 06 05 5 4 3 2 1

Library of Congress
Cataloging-in-Publication Data

Dent, Dorothy
 Painting four seasons of fabulous flowers / Dorothy Dent.
 p. cm.
 Includes index.
 ISBN 1-58180-602-7 (pbk. : alk. paper)
 1. Flowers in art. 2. Seasons in art. 3. Acrylic painting--Technique. I. Title.

 ND1400.D36 2004
 751.4'26--dc22
 2004053676

Editor: Holly Davis
Production Coordinator: Kristen Heller
Designer: Karla Baker
Interior Layout Artist: Camille DeRhodes
Photographer: Christine Polomsky

fw
F+W PUBLICATIONS, INC.

About the Author

Dorothy Dent began teaching decorative painting classes in 1972, soon growing her home studio into the nationally known Painter's Corner shop and studio in Republic, Missouri. She began self-publishing painting instruction books in 1980 and has published 29 titles since then. Her painting series, *The Joy of Country Painting*, appeared on PBS, and Bob Ross published two companion books. Her work has appeared in many decorative painting magazines, including *Decorative Artist's Workbook*. Besides *Painting Four Seasons of Fantastic Flowers*, Dorothy has also published *Painting Realistic Landscapes with Dorothy Dent* for North Light Books. Dorothy continues to teach not only in her shop but all over the United States and in Canada, Japan, Argentina and Australia. Her schedule and art can be seen on her Web site, www.ddent.com.

METRIC CONVERSION CHART

To Convert	To	Multiply By
Inches	Centimeters	2.54
Centimeters	Inches	0.4
Feet	Centimeters	30.5
Centimeters	Feet	0.03
Yards	Meters	0.9
Meters	Yards	1.1
Sq. Inches	Sq. Centimeters	6.45
Sq. Centimeters	Sq. Inches	0.16
Sq. Feet	Sq. Meters	0.09
Sq. Meters	Sq. Feet	10.8
Sq. Yards	Sq. Meters	0.8
Sq. Meters	Sq. Yards	1.2
Pounds	Kilograms	0.45
Kilograms	Pounds	2.2
Ounces	Grams	28.3
Grams	Ounces	0.035

Acknowledgments

First I want to thank God for giving me some measure of ability to paint and teach. It is an enjoyable way to earn a living. The best thing for me has been meeting all the wonderful people over the years, many of whom have become dear friends. Without painting I would never have met them. I even met my husband in painting class!

I also want to thank my wonderful staff at Painter's Corner. The gals who work for me have been with me for many years. Without their loyalty I would not be able to do all that I do. Thank you Celia, Becky, Pam, Marcia and Jean.

Many thanks also to my husband, D.A. Garner, who always supports all that I do and who helps in many ways.

A huge thanks also to North Light Books and especially to Kathy Kipp and Holly Davis, with whom I have worked closely in the completion of this book as well as my first North Light book, *Painting Realistic Landscapes with Dorothy Dent*. I appreciate the opportunity to do books for such a great company.

TABLE OF CONTENTS

Spring

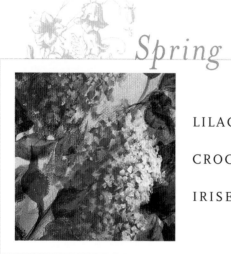

Summer

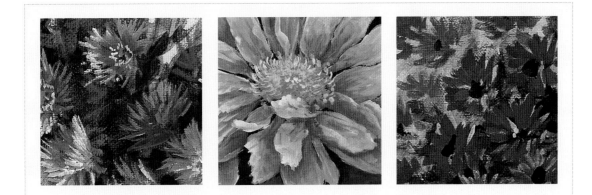

Autumn

Winter

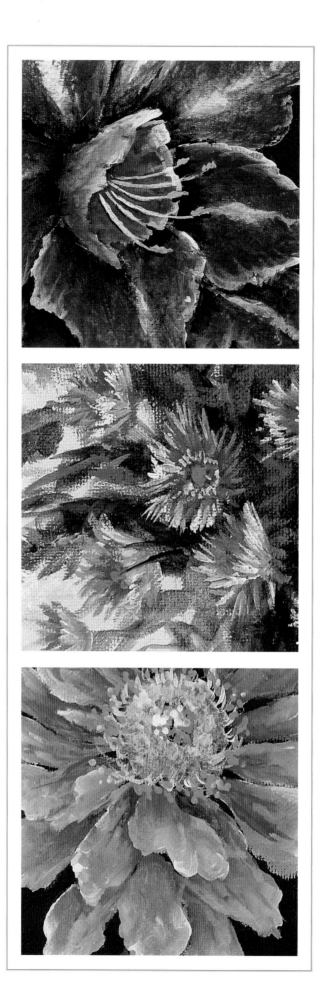

INTRODUCTION

as some of you may know, I am basically a landscape artist who usually paints in oil. However, I do enjoy working in acrylic as well. Painting in any medium and of any subject matter follows the same general rules. You work with light and dark values to create depth and shape. It matters not if you paint trees, mountains, flowers or the nose on someone's face. You still work with light and dark and use color to describe what you are painting. The techniques can be a bit different when you go from one medium to another, but it doesn't take long to discover how the paint should be applied for the best results. Painting is fun and exciting in every medium, and I love painting everything. Don't be afraid to try different subject matter and mediums. You may find real enjoyment in something you have never tried before.

The great thing about painting books such as this is that they give everyone who desires to paint the chance to do it. There are many wonderful instruction books available, great teachers all over the country and many painting shops where anyone can learn. You do not need to be extra talented in art to enjoy painting and learning. All you need is the desire to do it. The rest will follow. In this book are patterns for you to use as your guide. Each full-color step will make your painting progress easily. Painting, like anything else you wish to excel in does take practice, but the practice is fun, and you can be proud of what you're doing as you go.

Painting has been my career for many years, but there is always more to learn and new things to paint. The joy is still there and hasn't grown stale. Paint for pleasure. Paint to escape life's problems (for how can you worry about life's problems when you are painting a beautiful rose?). Sometimes you can even paint to make money, and it's still fun!

So follow along with me as we work through this book. You'll find some projects simple and some harder. When you're finished, you'll have beautiful floral paintings to display for all seasons of the year. Let's get started!

MATERIALS

BRUSHES

Good brushes are essential to good painting. For the projects in this book, I used the Martin/F. Weber Museum Emeralds, which have a nice feel to them—not too soft, not too firm.

The good news is that you can paint beautiful flowers with a handful of brushes, as you can see from the sidebar below.

If you prefer, you may use brights instead of flats. The two types are interchangeable for these projects. I prefer flats, which have a shorter bristle, but some people prefer brights. If you already own one type, there's no reason to buy the other unless you want to experiment.

Good brushes require good care. After your painting session, clean your brushes carefully with soap and water. Work the hair back to its original shape and allow it to dry. Store brushes in an upright container so that the bristles aren't bent from pushing into something.

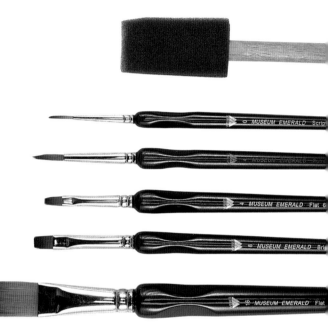

Brush types and sizes
From top to bottom: 1-inch (25mm) sponge applicator, no. 0 script liner, no. 4 pointed round, no. 4 flat, no. 8 bright, no. 16 flat.

BRUSHES USED IN THIS BOOK

Martin/F. Weber Museum Emerald:
• flat (series 6202) nos. 2, 4, 6, 8 and 16
• pointed round (series 6200) no. 4
• script liner (series 6205) no. 0
1-inch (25mm) sponge applicator *This brush is used for basecoating wood and canvases. The brand is not important.*

Not all these brushes are used for every project. Refer to the project materials list to determine exactly what you'll need to paint a particular flower.

PAINTS AND MEDIUMS

DecoArt Americana Acrylics All painting in this book is done with these bottled acrylics. I like to use a brand that isn't difficult to find, and most painting shops carry this one. Also, the range of colors offered in bottled acrylics is large, so students don't have to do as much mixing as they would with tube acrylics.

Martin/F. Weber Gesso Gesso is an acrylic-based white paint used to prepare surfaces for painting. It can be used under either oil or acrylic paint. Stretched canvases are already primed with gesso when you purchase them; however, the addition of two or three more smooth coats is very helpful when working with acrylic paints. The additional gesso will seal the textured surface of the canvas, making a smoother surface to work on.

DecoArt Easy Float This is a medium used to thin acrylic paint so it will flow smoothly and become more transparent. Although I have used water as my main medium in these paintings, I used Easy Float a few times when I didn't want the paint to dry quite as quickly.

SURFACES

I used two types of surfaces for the projects in this book:

Stretched canvas Most projects are done on this surface, which you can find ready-made in craft and painting supply stores. I used only standard sizes. Choose a smooth-surface canvas. Portrait grade is best.

Wood Wood is a great surface for painting in acrylic, as it is very smooth. Sealing the surface keeps the paint from soaking into the wood.

Specific preparation instructions for both stretched canvas and wood are on page 14. Of course, you can paint these projects on fabric, ceramic, tile or any other surface you prefer, as long as you know how to prepare and finish the surface. If in doubt, your local craft or painting supply store is a good source of advice.

tip Having trouble locating a particular material? See Resources on page 126.

OTHER MATERIALS

The following materials will round out your painting supplies:

Sandpaper Use fine-grit sandpaper for smoothing wood surfaces. Most wood designed for decorative painting is already quite smooth. You need only a slight touch-up in most cases.

Tack cloth This cloth works well for removing any sanding residue. Wipe the wood gently after sanding.

J.W. etc.'s First Step Wood Sealer I recommend this particular product for sealing wood before basecoating. Apply it with a sponge brush or an old bristle brush. Sand lightly after the sealer is dry.

Tracing paper or acetate Either one can be used for tracing patterns. Clear acetate is more expensive than tracing paper, but you can see through acetate perfectly. For detailed patterns this is a big help.

Fine-tip permanent marker If you decide to trace your pattern on acetate, you'll need one of these.

Tape Use this to hold the pattern in place while you trace.

White and black graphite paper Graphite paper works like carbon paper to transfer pattern lines to the painting surface. Actual carbon paper should not be used because it is somewhat greasy, causing the paint to slip off the lines. The color of graphite paper you use depends on the lightness or darkness of your painting surface or basecoat. On light surfaces use black graphite paper; on dark surfaces use white.

Stylus, pen, pencil Any of these can be used to transfer the pattern to the painting surface.

Brush basin This specially made container holds water for cleaning brushes. Brush basins have a grid at the bottom, which is helpful for removing paint from the brush. They usually have two separate sections for water, so you can have dirty water and cleaner water.

Palette paper This is a specially prepared paper on which to place and mix the paints you need for a particular project. See page 15 for my preferred palette setup.

Paper towels I use a damp paper towel on a sheet of palette paper to hold the paint. Other uses include wiping the brush and general cleanup.

Palette knife This handy tool is used for moving paint around on the palette.

Hair dryer Use this to speed up paint drying between steps.

Table easel This is an optional item, but I prefer to have my work up in front of me. With a table easel it's easier to see what you're doing, and you can step back and view the project from a distance.

Eraser Any good art eraser works for removing tracing lines that don't get covered with paint.

Brush cleaner Acrylic brush cleaner is great, but soap and water do fine. Be sure to clean those brushes well, or you will be replacing them very quickly.

Varnish If you like a spray varnish, DecoArt Americana Acrylic Sealer/Finisher is good for both the wood and canvas projects. Follow the directions on the can. If you like a brush-on varnish, try J.W. etc.'s Right-Step Water Base Clear Varnish. Always use a very soft flat brush for brush-on varnish, and remember to clean that brush well with soap and water when you're done. All varnishes come in matte, satin or gloss. The choice is yours. I prefer satin for most things.

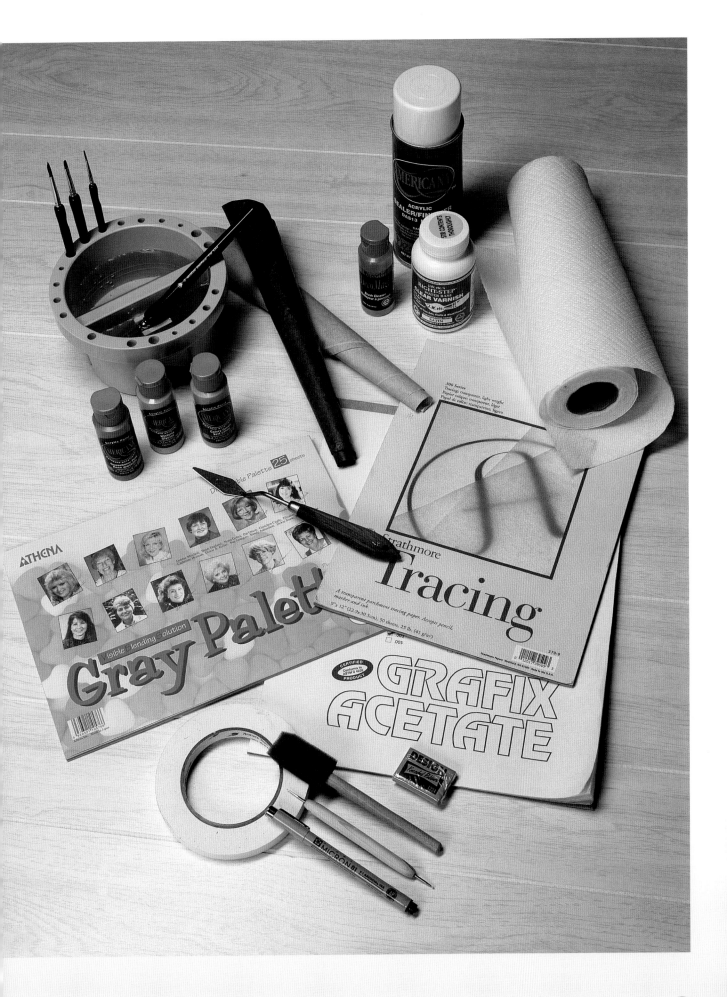

TECHNIQUES

PREPARING SURFACES

After choosing the surface for your project, take the time to properly prepare it for painting. I know this isn't the fun part and you're anxious to get to the real painting, but please take the time to prep the surface in the right way. Otherwise your finished piece will not be as nice as it could be.

Wood If the wood is very rough, sand it until smooth with fine-grit sandpaper. Remove the sanding dust with a tack cloth. Next, apply a wood sealer, which goes down into the pores and seals them so that the paint will not soak into the wood. Once the sealer is dry, sand the surface again with fine-grit sandpaper. Then wipe off the residue with a tack cloth. The wood can then be painted according to the project directions.

Stretched canvas I prefer a smooth-textured canvas such as portrait grade. The smoother the canvas, the easier it is to paint on with DecoArt Americana acrylics, which are a thinner consistency than tube acrylics. Basecoat each canvas with two or three coats of gesso, allowing drying time between coats. The gesso will work into the weave of the canvas, sealing it as well as filling in any roughness. When the last coat of gesso dries, the canvas is ready for painting.

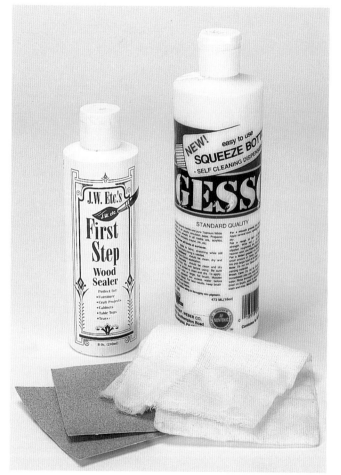

SURFACE PREPARATION MATERIALS
Clockwise from upper left: J.W. etc.'s First Step Wood Sealer, Martin/F. Weber Gesso, tack cloth, fine-grit sandpaper.

TRACING AND TRANSFERRING THE PATTERN

If you want to use the patterns in this book at the same size I did, you will have to enlarge them with a photocopier. The enlargement percentage is given with each pattern. Once you have the desired-size pattern, trace it onto either tracing paper or acetate (see page 12).

To transfer the pattern onto your painting surface, place the coated side of a sheet of graphite paper against the surface. For dark surfaces use white graphite paper and for light surfaces use black. Then place your traced pattern on top of the graphite paper and tape it in place. Go over the pattern lines with a stylus, pen or pencil. As you press down with your tool, the graphite coating will adhere to the painting surface, transferring the pattern lines.

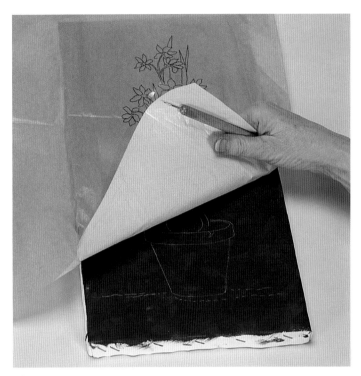

TRANSFERRING THE PATTERN

SETTING UP THE PALETTE

My usual palette for acrylics is disposable palette paper with a shiny, slick surface. I lay a damp, folded paper towel on one side of the palette paper and squeeze the paint colors onto it. The paints stay wet for hours. I mix colors as they are needed on the dry palette paper.

ACRYLIC PALETTE SETUP

MIXING COLORS

All the mixes in this book are brush mixes with
no specific proportions of paint. The predomi-
nant color is listed first in the mix. I like to
work with variations of the paint mixes. If the
mix seems too dark, simply add more of the
light value(s) in the mix. If it seems too light,
add more of the dark value(s).

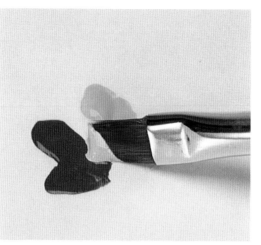

1 SQUEEZE OUT THE COLORS
On the palette, squeeze out a dab of each of the
colors you will use in the mix. To better control
the values, add the second color to the first a little
at a time.

2 MIX THE COLORS
Loosely mix the colors with you
brush. Don't try to brush-mix a
large pile of paint. Just mix a lit
tle at a time. You will have some
variation in the colors, and that
is good.

CORNER LOADING A BRUSH

With a corner-loaded brush you can tuck the stronger color right where you want the darkest value.
Because the brush is wet, the color thins out as you stroke across an area and gives you a nice soft
color blend. This works great when painting petals, leaves and other areas where you need dark val-
ues blending into lighter values.

1 LOAD THE CORNER
To corner load a brush, first dip the brush in water
and blot out most of the moisture. The brush
should still be wet. Then dip the corner of the
brush into the paint.

2 NOTE THE CORNER-LOADED BRUSH
This is how your brush looks after loading the corner.

3 DISTRIBUTE THE PAINT
Brush the flat of the brush across
the palette a couple of times to
distribute the paint down the
bristles. Now you're ready to go
to your project and lay on the
color where you want it.

LEAF AND PETAL CURLS

Leaf and petal curls help create realistic looking flowers. A little practice with this technique is worth the time. This demonstration shows the curl on a leaf, but the same technique is used on petals.

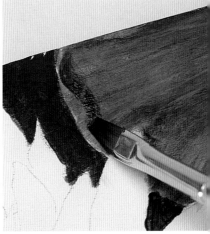

1 START WITH A CORNER LOAD
Begin by corner loading a damp brush with the shadow color. Placing the corner of the brush with the paint at the edge of the leaf, move inward.

2 CREATE THE HIGH POINT
At the high point of the curl, come back down.

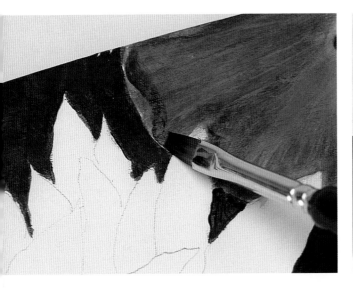

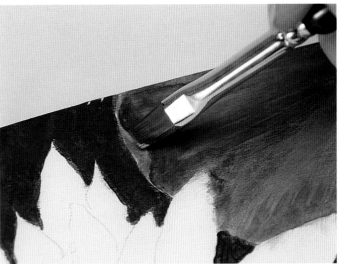

3 END CURL AND SOFTEN
End at the leaf edge. You may want to soften the edge of the curl with a moist brush.

4 HIGHLIGHT
Sometimes you may want to add more highlight to the curled edge with a lighter value.

SPRING

Spring unlocks the flowers
to paint the laughing soil.

Reginald Heber

spring! glorious spring! It has to be my favorite season—a time of new beginnings, new growth and fresh starts. Marking the end of cold winter days, spring brings the excitement of first leaves opening, flowers peeking out of the damp ground and fragrant blossoms.

I love the smell of lilacs—especially the older varieties. The lilacs in this book aren't difficult to paint because the flowers are mostly dabbed in. I chose not to paint these with great detail, but relied on the color to loosely describe the flowers.

The crocus is one of the first spring flowers to bloom. I love its cheery brightness among the brown leaves fallen from winter trees. I painted mine on canvas, but you might consider painting this project, as well as the others, on different types of surfaces, such as wood, tile, glass or fabric.

Irises, or "flags," as my grandmother called them, are another early spring flower. They're standbys in old-fashioned gardens, but their beauty reminds me of the more exotic orchid. Irises come in so many colors, it's hard to know which to plant—or paint. For extra fun, try painting irises in other colors as well as the ones I chose.

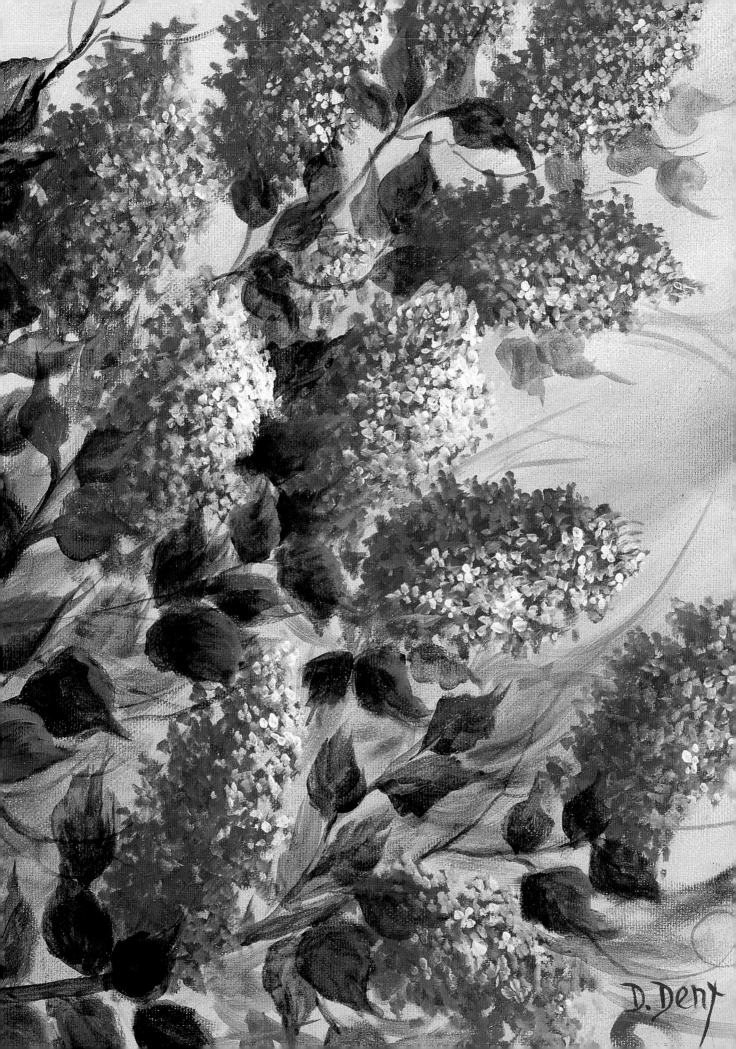

COLORS

DecoArt Americana Acrylics

Black Forest Green Golden Straw Hauser Light Green

Light Buttermilk Pansy Lavender

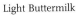

Payne's Grey Primary Blue Russet

Violet Haze Williamsburg Blue

lilacs

Lilacs are fun to paint. You need only a few placement lines so you know where the flowers go. For a good solid look on the blossoms, overlap strokes as you fill in each flower. The leaves are just filler and are very loosely done. After you see how easy these lilacs are to paint, you may want to try them on a piece of furniture, a lamp shade or in a corner of your bathroom wall. You're limited only by your imagination.

SURFACE
• Stretched canvas, 16" × 12" (41cm × 31cm)

BRUSHES
• no. 8 flat
• no. 16 flat
• no. 4 pointed round
• no. 0 liner
• 1-inch (25mm) sponge brush

ADDITIONAL SUPPLIES
• Gesso
• Black graphite paper
• Stylus, pen or pencil
• DecoArt Easy Float
• DecoArt Americana Acrylic Sealer/Finisher

D. Dent

PATTERN

This pattern may be hand-traced or photocopied for personal use only.
Enlarge at 154 percent to bring up to full size.

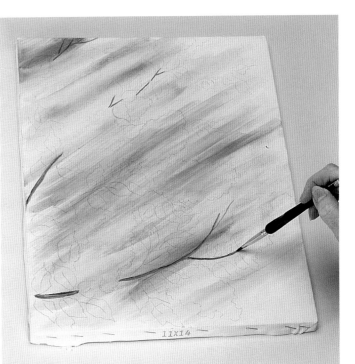

1 | **BASECOAT AND STREAK IN BACKGROUND**
Prepare the canvas as described on page 14. Basecoat with two coats of Light Buttermilk and a 1-inch (25mm) sponge brush. Brush on light diagonal strokes of Williamsburg Blue with a no. 16 flat. Work for a streaky look that lets some Light Buttermilk show through. Let dry.

2 | **TRANSFER PATTERN AND PAINT STEMS**
Transfer the pattern with black graphite paper. Paint the larger stems with a brush mix of Payne's Grey + Russet, using the chisel edge of a no. 8 flat.

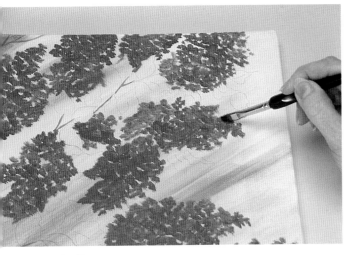

tip Work for soft, irregular edges on the flowers.
The outline is only a suggestion of the flower's edge.

3 | **BASE LILACS**
Base the flowers with Pansy Lavender on a corner-loaded no. 8 flat. Tap in the color and make sure the outer edges are uneven, the outermost dots going a bit past the tracing line.

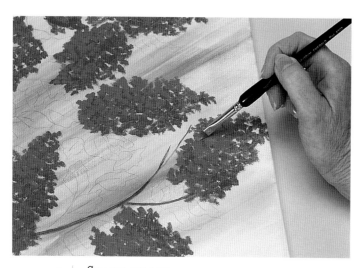

tip Remember that the paint will be very thin for shading. You can build up several layers if needed for darker shadows.

4 | SHADE LILACS

Using the same brush, tap in some corner-loaded Violet Haze on the shadowed side of the lilacs.

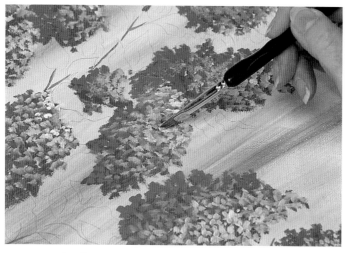

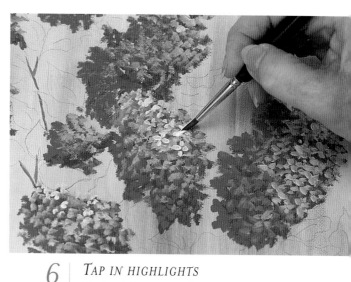

5 | PAINT SCATTERED FLORETS

Scatter some four-petal florets in the highlighted areas, using Light Buttermilk on the tip of a no. 4 pointed round.

6 | TAP IN HIGHLIGHTS

Tap in Light Buttermilk highlights as you did with the previous flower colors. Occasionally pick up a bit of Pansy Lavender or Violet Haze to give some petals a midtone. Keep the lighter tones on the light side of the flower rather than going all the way across. You want a light side and a dark side, but avoid making the colors stop on a line in the center of the flower.

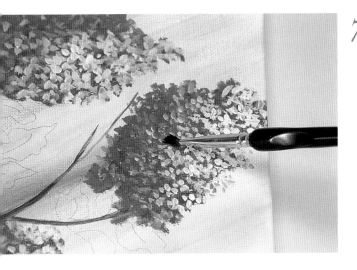

7 | GLAZE

Returning to the no. 8 flat, glaze Primary Blue + Easy Float on the shadowed side of the lilacs. If the color is too strong, blot immediately with a paper towel. Once this shading is done, strengthen the highlights with Light Buttermilk, if needed.

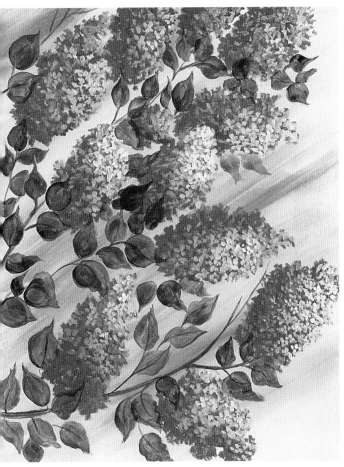

8 | ADD LEAVES AND STEMS

Loosely block in the leaves with Payne's Grey + Black Forest Green on the flat of the no. 8 flat. Just stroke in the sides and fill in the middle. Create some darker leaves by adding a little Russet to your brush mix. Let the color values vary. With the no. 0 script liner, add some leaf stems in the same color as the leaves.

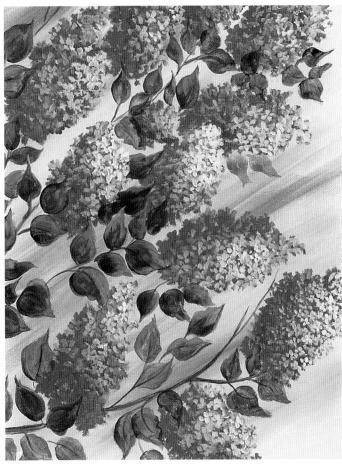

9 | ENHANCE AND HIGHLIGHT

If necessary, enhance the color variations by going over some of the leaves with the same colors used in the previous step. Then highlight the leaves with Hauser Light Green.

10 | *ADD FILLER LEAVES AND TWIGS*
With the no. 8 flat, stroke some shadowy filler leaves and twigs in the open spaces of the background with Williamsburg Blue, sometimes adding a touch of Black Forest Green. These shadow leaves don't necessarily need a distinct leaf shape.

11 | *ADD BACKGROUND GLAZE*
Glaze an area of thin Golden Straw in the background near the middle flower, using the no. 8 flat.

12 | *ADD TWIGS AND VARNISH*
Add a curly twig or two with thinned Payne's Grey + Russet and the no. 0 script liner.

Let the painting dry completely and then spray with DecoArt Americana Acrylic Sealer/Finisher.

tip If your linework is not thin and smooth, your paint is not wet enough. Add more water to the paint, twirl the brush to a sharp tip and don't press too hard. Keep just the tip down as you pull it.

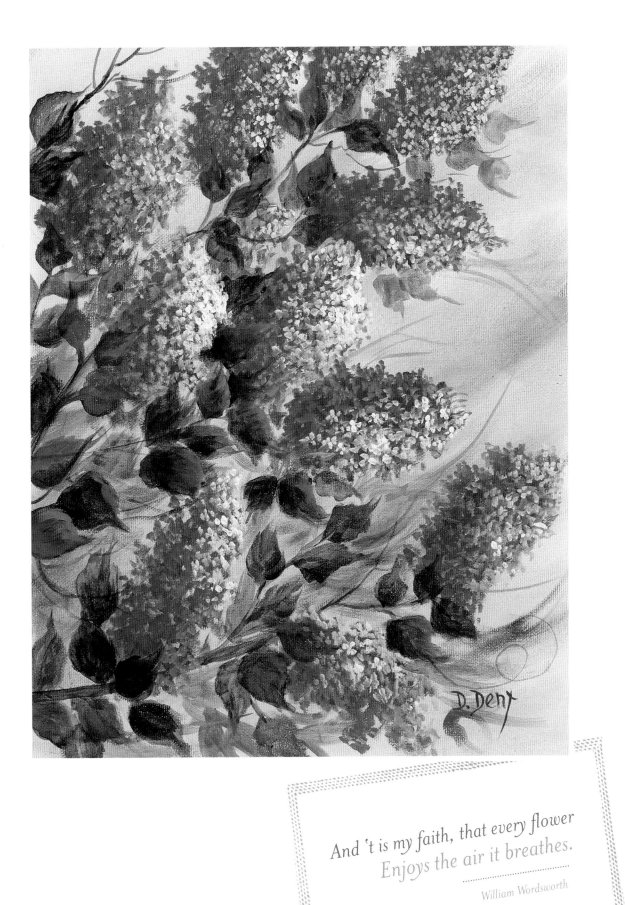

And 't is my faith, that every flower
Enjoys the air it breathes.

William Wordsworth

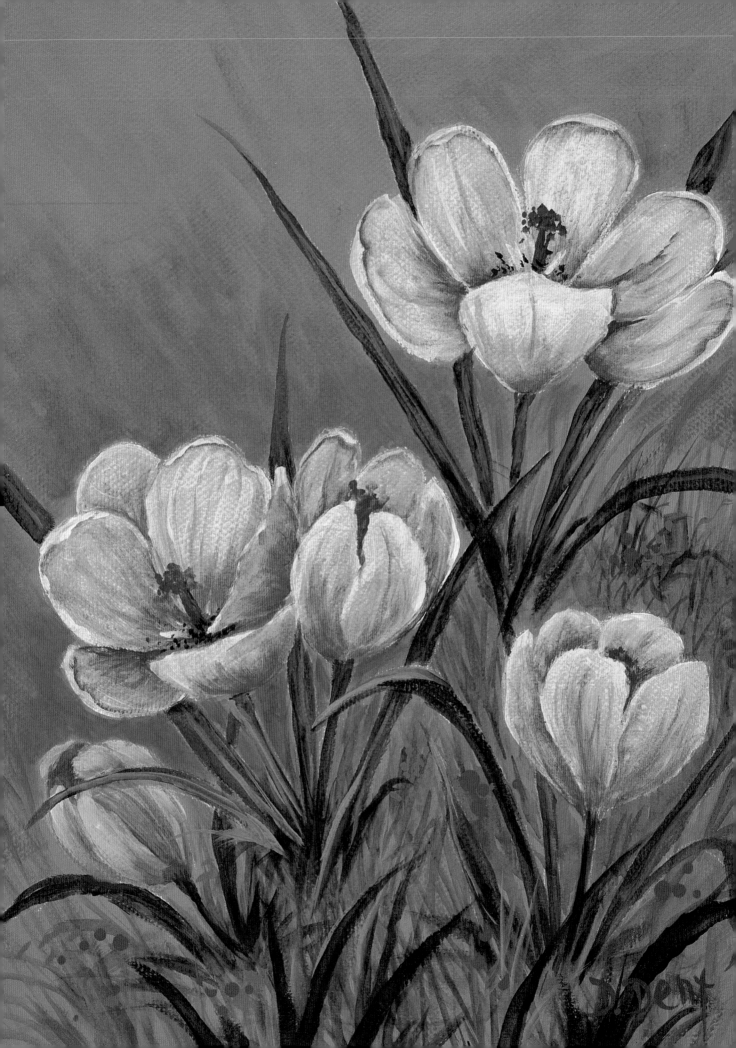

crocuses

In many areas crocuses have the fine reputation of being the first flowers of spring. Sometimes they even pop up in the snow if they're in a sheltered area where the sun warms the ground a bit. Their bright colors are ever so welcome after a cold winter. These crocuses are easy to paint because the petals are rather large.

COLORS

DecoArt Americana Acrylics

Black Forest Green Cadmium Red Cadmium Yellow

Green Mist Hauser Light Green

Pansy Lavender Russet Titanium White

Violet Haze Yellow Light

SURFACE
• Stretched canvas, 10" × 8" (25cm × 20cm)

BRUSHES
• no. 8 flat
• no. 0 script liner
• 1-inch (25mm) sponge brush

ADDITIONAL SUPPLIES
• Gesso
• White graphite paper
• Stylus, pen or pencil
• DecoArt Easy Float
• DecoArt Americana Acrylic Sealer/Finisher

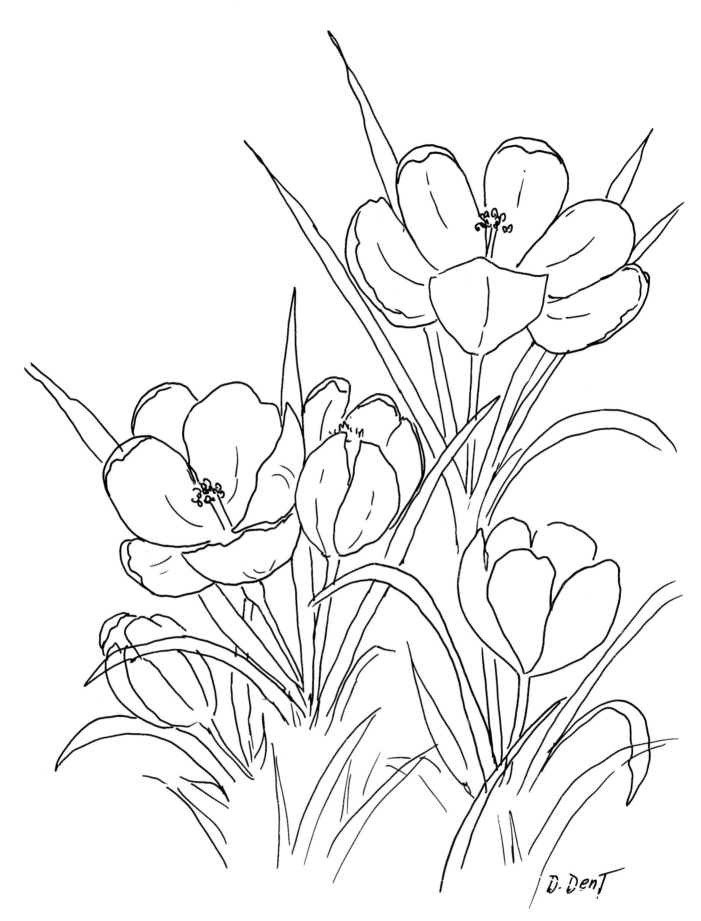

PATTERN

This pattern may be hand-traced or photocopied for personal use only.
Enlarge at 111 percent to bring up to full size.

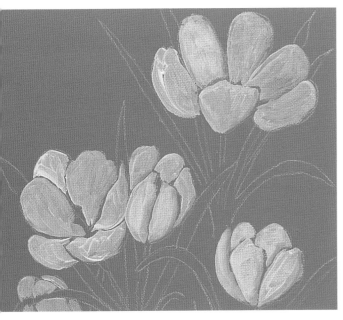

1 | BASE AND TRANSFER

Prepare the canvas as explained on page 14.
Basecoat with two coats of Green Mist, using a
1-inch (25mm) sponge brush. Transfer the pattern
with white graphite paper. Basecoat the flower petals
with Titanium White, using a no. 8 flat. Leave a
thin line of petal separation.

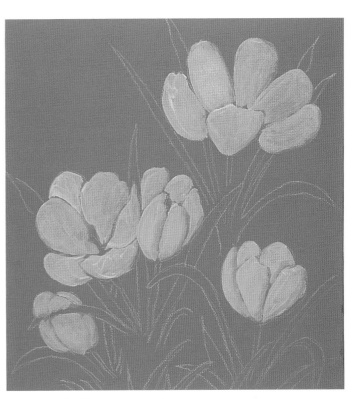

2 | BASE PETALS AGAIN

With the same brush, basecoat again with
Cadmium Yellow.

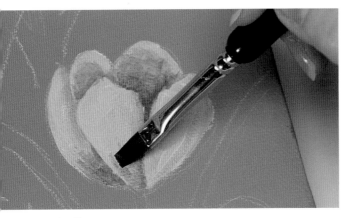

3 | SHADE PETALS

Dampen a no. 8 flat with water. Blot it slightly on
a paper towel and corner load with a little Russet +
Cadmium Red. Start your shading at the base of
each petal, working across. Keep the paint moist
by frequently dipping the brush into the water to
thin the paint where the shading ends. If necessary,
clean the brush and add a little Cadmium Yellow to
the petals, blending into the unshaded area to make
a smoother transition of colors.

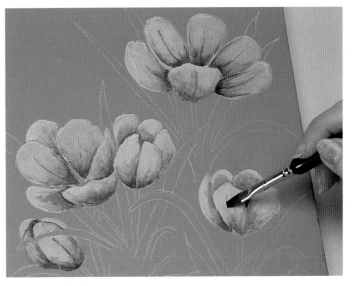

4 | ADD PETAL VEIN LINES

With Russet + Cadmium Red on the chisel edge of a
no. 8 flat, bring vein lines up the middle of the petals.
Curve the veins slightly to conform to the petal.

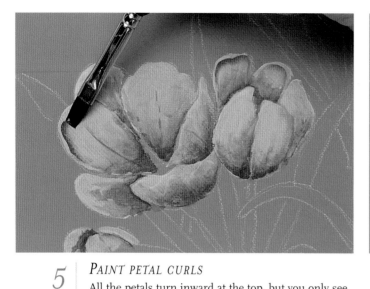

5 | *PAINT PETAL CURLS*
All the petals turn inward at the top, but you only see the curled edges on the back petals. These curls are indicated with a bit of shading. Dip the no. 8 flat in water, blot slightly and corner load in Cadmium Red + Russet. Stroke the palette a few times to soften the color. Begin the shading at the edge of the petal, come in a bit and then go back to the edge of the petal. This creates a shadow that defines the curl.

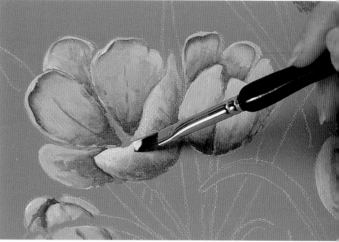

6 | *HIGHLIGHT PETALS*
Corner load the no. 8 flat with a light value of Titanium White + Yellow Light. Stroke in a bit of highlight to the petal ends, working across the petals with the light mix to the outside.

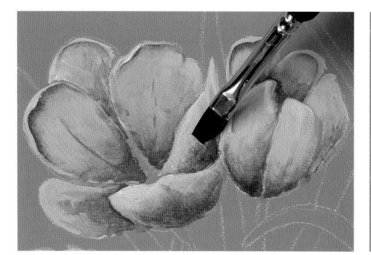

7 | *TINT PETALS*
With a no. 8 flat, add a tint of transparent Violet Haze over the shaded area of some of the petals.

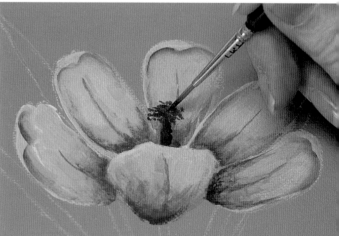

8 | *ADD STAMENS*
Using the no. 0 script liner, paint the stamens with Russet. The ends of the stamens are dotted on with the point of the brush and more Russet.

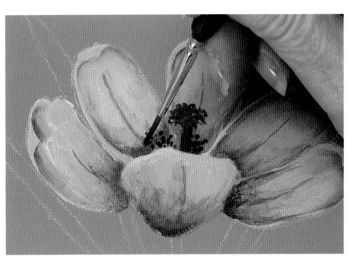

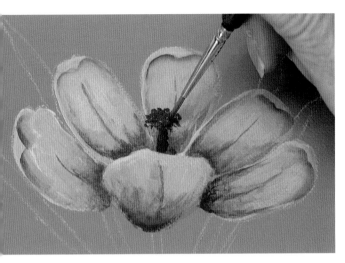

9 | *ADD MORE STAMEN DOTS*
Still using the script liner, brush-mix Cadmium Red + Russet, using a bit more red, and add more dots to the stamens.

10 | *DETAIL THE CROCUS CUP*
Now add a few dots in the bottom of the cupped flower with Black Forest Green + Russet, leaning heavier to the green.

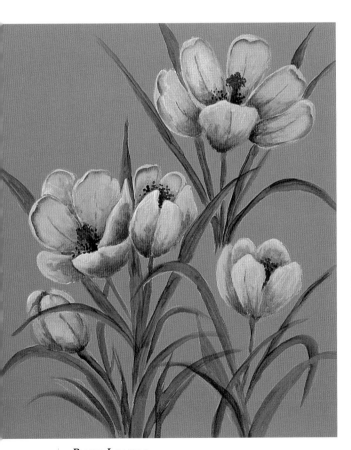

11 | *BASE LEAVES*
Using a no. 8 flat, base in the leaves with a brush mix of Black Forest Green + a bit of Russet. Vary the mix slightly as you paint, and moisten with water on the brush as needed.

12 | *HIGHLIGHT LEAVES*
Highlight the leaves with the same brush, using thinned Hauser Light Green.

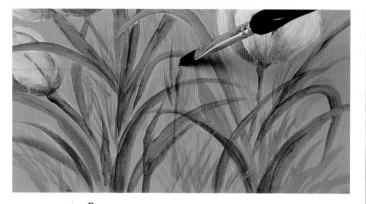

13 | PAINT GRASS–BLADES

Using the chisel edge of a no. 8 flat, paint short loose grass-blades with very moist Black Forest Green + Russet. Some blades will be darker and some lighter, depending on the moisture in the brush.

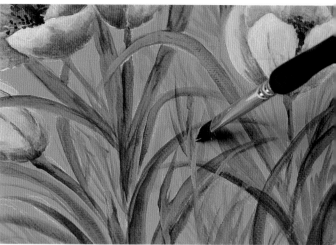

14 | HIGHLIGHT GRASS–BLADES

Highlight the grass with thinned Hauser Light Green.

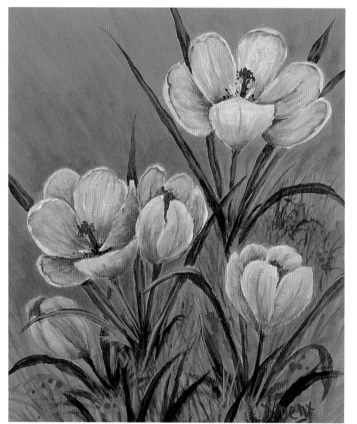

15 | ADD WASHES AND FLOWERS

Wash in some Violet Haze + Easy Float around the flowers. Stroke this in rays coming out from the flowers, letting the color fade gradually as you move away from the flowers. Build up the color gradually with thin coats until you feel it is enough. Dab a little Violet Haze into the grass with slightly heavier paint.

16 | ADD MORE BACKGROUND FLOWERS AND VARNISH

Dab in a few Pansy Lavender flowers with the handle end of the brush. Work for a loose, uneven look.

Let the painting dry completely and then spray with DecoArt Americana Acrylic Sealer/Finisher.

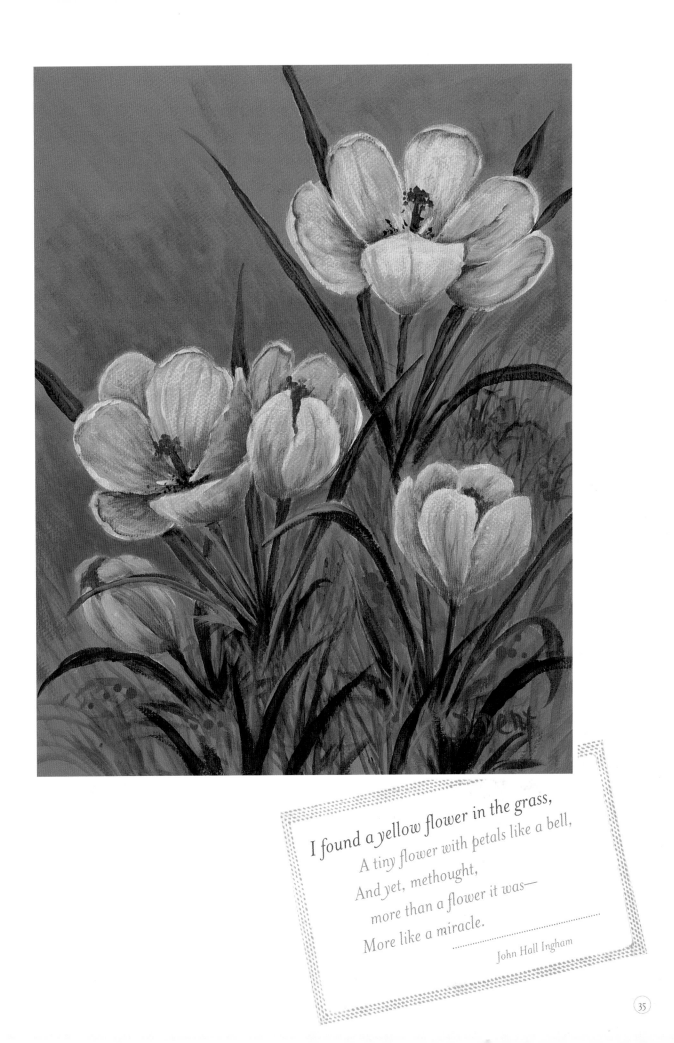

I found a yellow flower in the grass,
A tiny flower with petals like a bell,
And yet, methought,
more than a flower it was—
More like a miracle.

John Hall Ingham

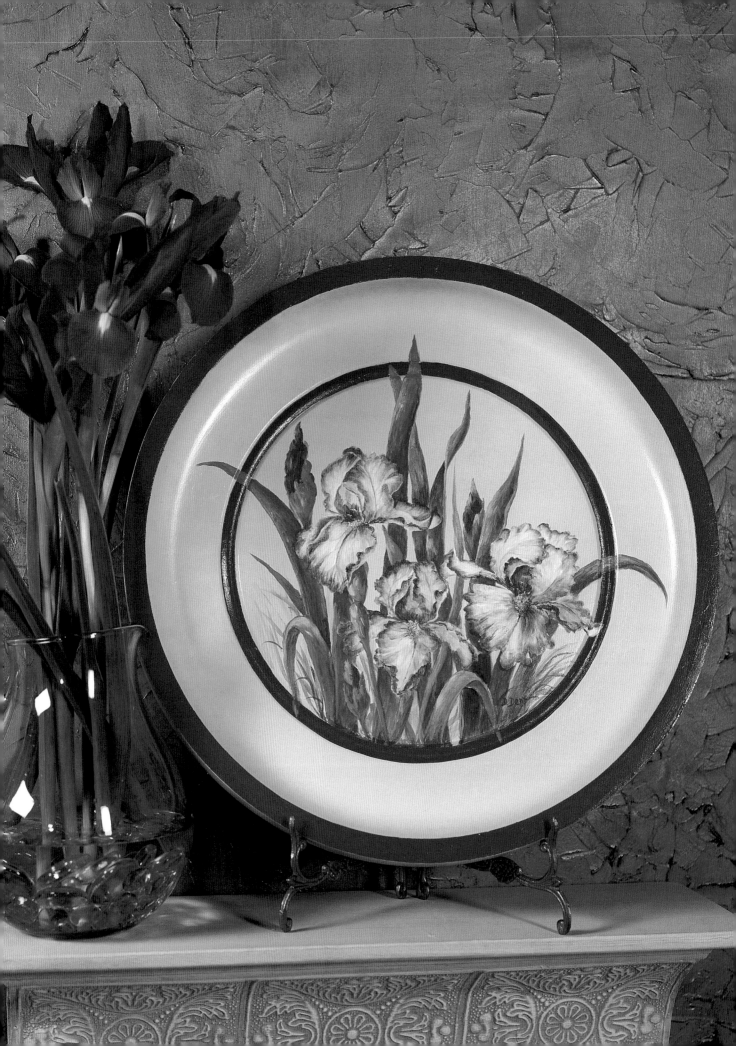

irises

If I had to find one thing wrong with the iris, it would be that it doesn't bloom long enough! But while it does, it's pure beauty, putting on a show each spring. Irises are hardy flowers, needing little care, although they like well-drained soil and sunshine. Painting irises provides a good lesson on creating ruffly petals. To avoid overblending, keep your strokes short as you work in the colors.

COLORS

DecoArt Americana Acrylics

Antique Gold Burnt Orange

Cadmium Yellow French Vanilla Green Mist

Hauser Light Green Light Buttermilk

Pansy Lavender Payne's Grey

SURFACE
- Round wooden bowl, 16" (41cm) diameter, #B162, from Wayne's Woodenware

BRUSHES
- no. 4 flat
- no. 6 flat
- no. 8 flat
- no. 0 script liner
- 1-inch (25mm) sponge brush

ADDITIONAL SUPPLIES
- Sandpaper
- J.W. etc.'s Wood Sealer
- Tack cloth
- Black graphite paper
- Stylus, pen or pencil
- DecoArt Easy Float
- DecoArt Americana Acrylic Sealer/Finisher

PATTERN
This pattern may be hand-traced or photocopied for personal use only.
Enlarge at 143 percent to bring up to full size.

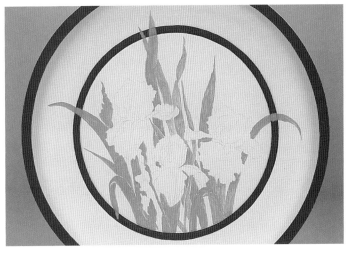

1 | *BASECOAT AND TRANSFER*
Prepare the bowl as explained on page 14. Basecoat all the bowl surfaces with two coats of French Vanilla, using a 1-inch (25mm) sponge brush. Basecoat the rings on the bowl with two or three coats of Pansy Lavender, using a no. 8 flat. Transfer the pattern with black graphite paper.

2 | *BASECOAT LEAVES*
Basecoat all the leaves with Green Mist, using a no. 6 flat.

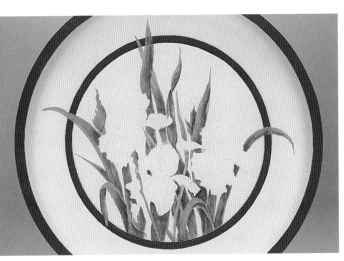

If you can paint one leaf,
you can paint the whole world.

John Ruskin

3 | *SHADE AND SEPARATE LEAVES*
With the same brush, shade the leaves with Pansy Lavender, adding touches of Payne's Grey in some of the darker areas. Lay in the shading so that it separates the leaves.

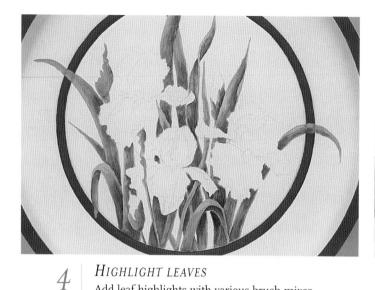

4 HIGHLIGHT LEAVES

Add leaf highlights with various brush mixes created with Hauser Light Green, Cadmium Yellow and Light Buttermilk. Your lights against darks help establish leaf separation, so add more shading if you feel it's necessary.

5 ADD COLOR TOUCHES TO LEAVES

Add touches of Burnt Orange + Light Buttermilk on the buds and leaves, still using the no. 6 flat.

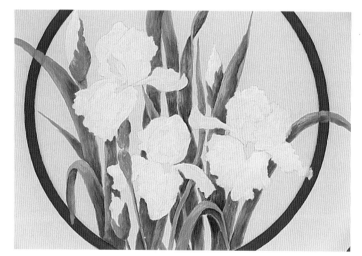

6 BASECOAT IRISES

When painting the irises, use the no. 8 flat for the larger areas and the no. 4 flat for the smaller areas. Start with a single basecoat of Light Buttermilk. The French Vanilla tint will show through, which is what you want.

Each flower is the soul
to blossoming nature.

Gerard de Nerval

tip As you pull the Pansy Lavender into the petals, be sure the basecoat is slightly damp so the Pansy Lavender will fade out and not leave a hard line. Also, avoid picking up the brush too quickly as you pull in.

7 | *PAINT AND BLEND PETAL EDGES*
For this step, paint one petal at a time. First brush on a thin coat of Easy Float to make the surface slightly damp. Then load one surface of the brush with Pansy Lavender and, with the color on top of the bristles, paint along the petal edges. Quickly stroke the color into the petal, following the contour. Blend by brushing back and forth, still following the contour. For smaller areas, you may need to use a corner-loaded brush. Add more Pansy Lavender where needed to darken for more contrast.

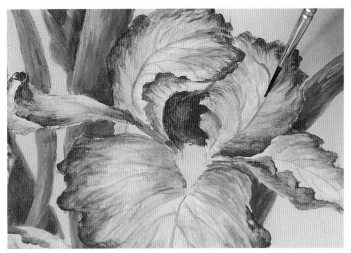

8 | *INCREASE LIGHT VALUES*
Add a bit more Light Buttermilk in the lightest part of some petals.

9 | *PAINT PETAL VEIN LINES*
Add faint petal vein lines with very moist Pansy Lavender and a no. 0 script liner.

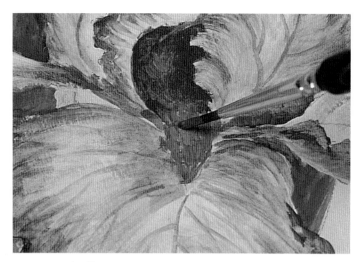

10 | *BASE IRIS BEARDS*
Lightly brush-mix Antique Gold + Burnt Orange with a no. 0 script liner and base in the flower beards.

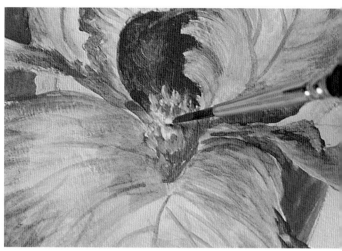

11 | *HIGHLIGHT IRIS BEARDS*
Still using a no. 0 script liner, highlight the beards with Cadmium Yellow and Cadmium Yellow + Light Buttermilk.

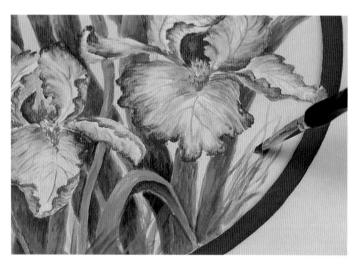

12 | *STROKE IN GRASS AND VARNISH*
Using the chisel edge of a no. 6 flat, stroke up some loose grass to fill in the sides of the painting at the bottom of the bowl. Use Green Mist, Hauser Light Green, Payne's Grey + Green Mist, and touches of Pansy Lavender.

Let the painting dry completely and then spray with DecoArt Americana Acrylic Sealer/Finisher.

tip Remember that light values against dark values separates all things. Increase your lights and darks as needed with additional paint for great contrast.

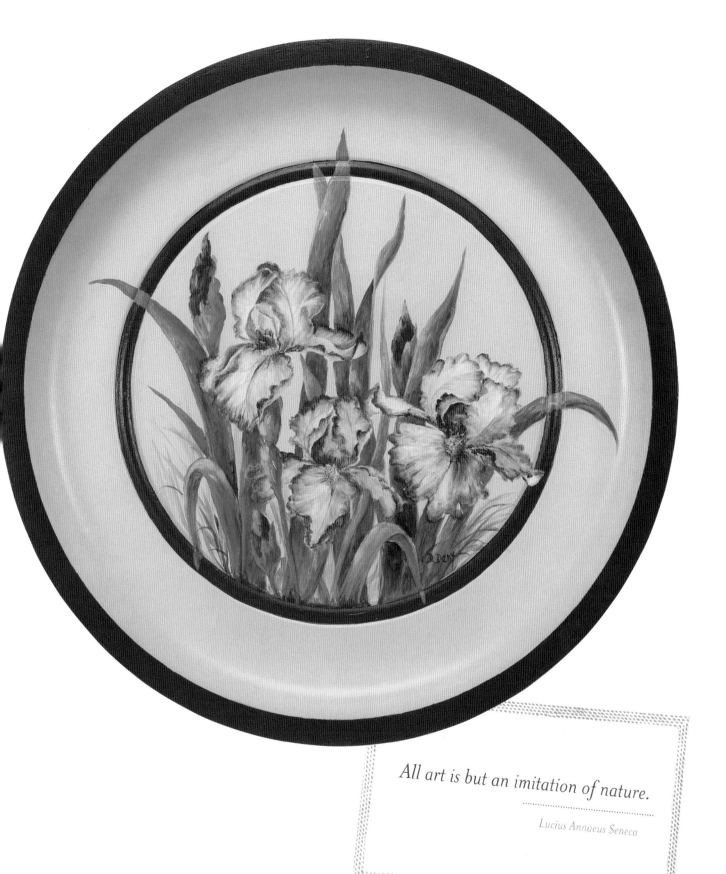

All art is but an imitation of nature.

Lucius Annaeus Seneca

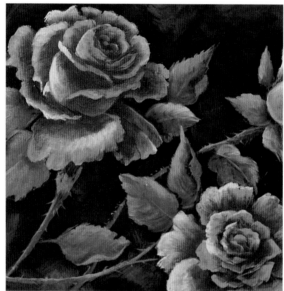

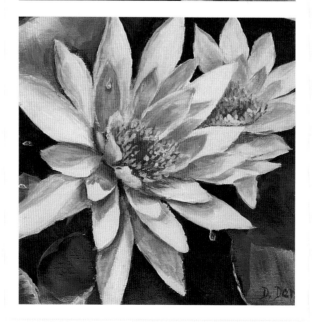

S U M M E R

No price is set
on the lavish summer.

James Russell Lowell

rich, vivid color! That's what summer brings to my mind—deep foliage greens and bright, beautiful floral displays at their peak. For this season I selected three distinct types of flowers, ranging from easy to a bit more challenging.

Queen Anne's lace represents our abundant wildflowers, which are just as beautiful as those we buy in nurseries and grow with care. It's a simple and enjoyable flower to paint—good for beginners.

From the roadside wildflower we move on to a favorite garden flower—the rose. There are many methods of painting roses, but with all of them you must use dark values against lighter values to show depth, highlight and shape.

Water lilies are both wild and cultivated, for they are now seen in many home water gardens as well as in ponds and lakes. I have toured several water gardens, which always seem peaceful and cool, even though the day may be hot. I love the strong contrast of the dark water and leaves against the lighter flowers, and the water lily's petal colors are so delicate, they just beg to be painted.

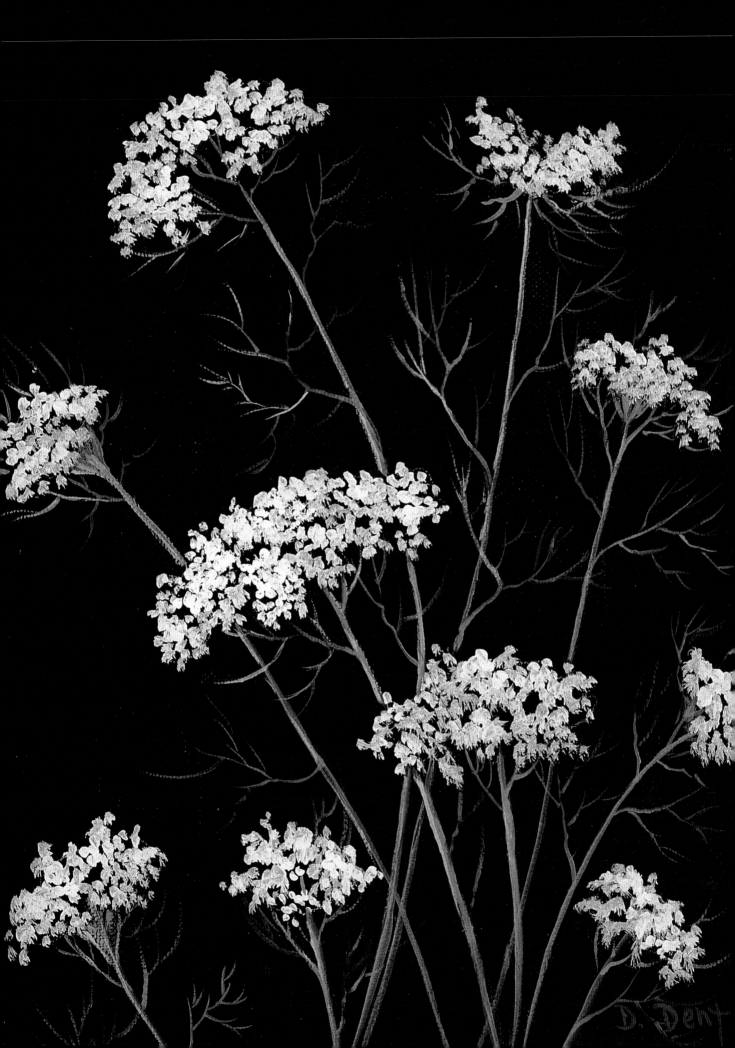

queen anne's lace

In the midwestern United States where I live, many summer fields and roadsides are white with the wildflower, Queen Anne's lace. I suppose it's a weed to some, but I love its lacy beauty. This flower provides a great lesson on using a liner to create tiny linework. The key is to properly thin the paint so it flows nicely from the brush.

COLORS

DecoArt Americana Acrylics

Black Plum Golden Straw

Hauser Light Green Light Buttermilk

SURFACE
• Stretched canvas, 12" × 9" (31cm × 30cm)

BRUSHES
• no. 4 pointed round
• no. 0 script liner
• 1-inch (25mm) sponge brush

ADDITIONAL SUPPLIES
• Gesso
• White graphite paper
• Stylus, pen or pencil
• DecoArt Americana Acrylic Sealer/Finisher

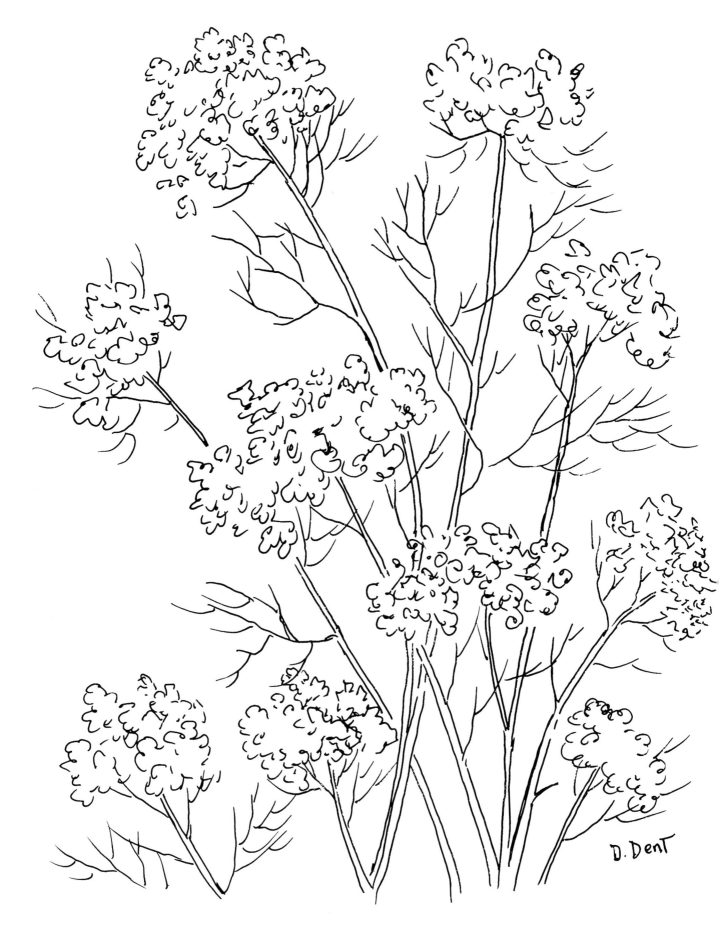

D. Dent

PATTERN

This pattern may be hand-traced or photocopied for personal use only.
Enlarge at 118 percent to bring up to full size.

1 | BASECOAT AND TRANSFER

Prepare the canvas as explained on page 14. Basecoat with two coats of Black Plum, using a 1-inch (25mm) sponge brush. Transfer the pattern with white graphite paper.

Flowers are words which even a babe may understand.

Bishop Arthur Cleveland Coxe

2 | TAP IN FLOWER HEADS

With Light Buttermilk on the tip of the no. 4 pointed round, tap in the white flower heads with little dots. Some dots will overlap, and some of the Black Plum background should be allowed to show through. Work for an irregular look to the outside edges, using the pattern only as a guide.

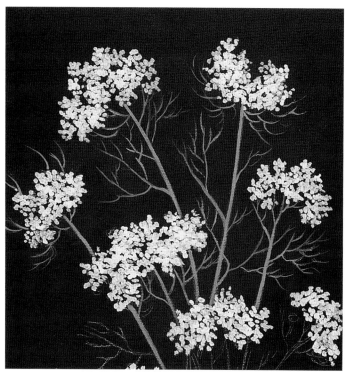

3 | *PAINT STEMS*
Fill in the stems and fine line work with Hauser Light Green. Use a no. 4 pointed round for the thicker stems and a no. 0 script liner for the finer ones.

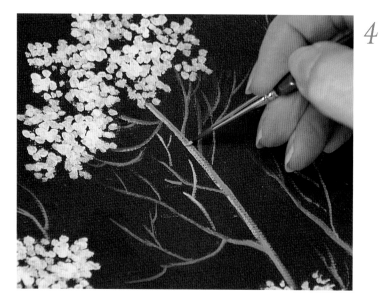

4 | *HIGHLIGHT STEMS AND VARNISH*
Highlight some areas of the stems with a brush mix of Golden Straw + Light Buttermilk, varying the proportions. Use a no. 0 script liner.

Let the painting dry completely and then spray with DecoArt Americana Acrylic Sealer/Finisher.

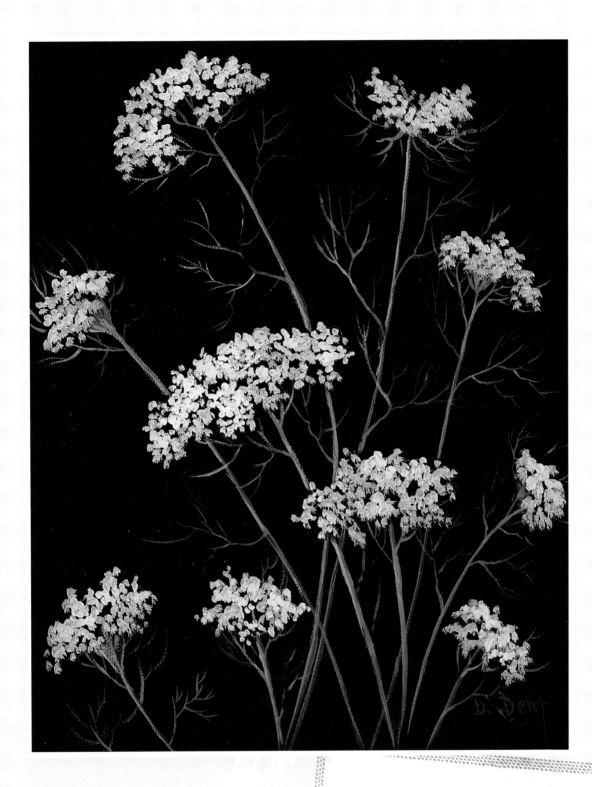

Like a great poet, Nature knows
how to produce the greatest effects with
the most limited means.

Heinrich Heine

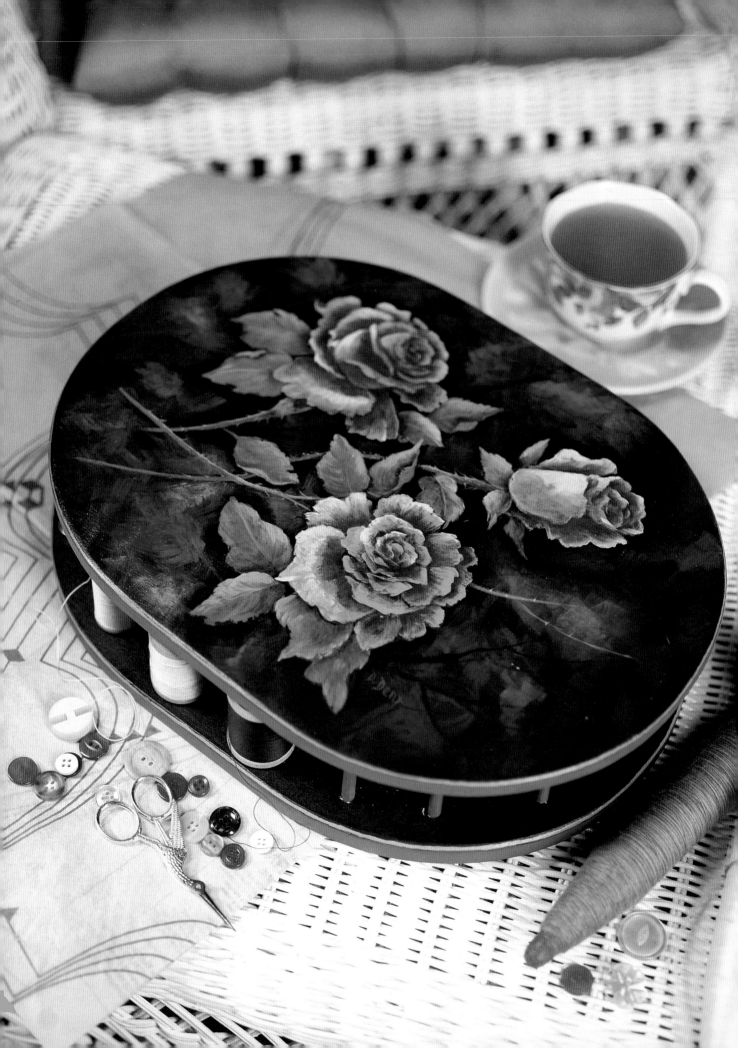

roses

Who does not love roses? Almost every flower painter at some point paints this beautiful flower. The thing to watch for in painting any multipetal flower is maintaining petal separation to create dimension. The dark areas define the shapes, so you don't want to lose them. If you do lose your darks, just paint them back in, and the petals will stand away from each other again. In addition, brushing on the paint in thin layers gives a nice blended look to rose petals and leaves.

COLORS

DecoArt Americana Acrylics

Cadmium Yellow

Coral Rose

Deep Midnight Blue

Hauser Light Green

Lamp Black

Leaf Green

Light Buttermilk

Napthol Red

Payne's Grey

Peaches 'n Cream

Sable Brown

SURFACE
- Wooden sewing box, 10 ¼" × 13" (26cm × 33cm) lid, from Custom Wood by Dallas

BRUSHES
- no. 4 flat
- no. 8 flat
- no. 0 script liner
- 1-inch (25mm) sponge brush

ADDITIONAL SUPPLIES
- Sandpaper
- J.W. etc.'s Wood Sealer
- Tack cloth
- Wood glue
- White graphite paper
- Stylus, pen or pencil
- DecoArt Easy Float
- DecoArt Americana Acrylic Sealer/Finisher

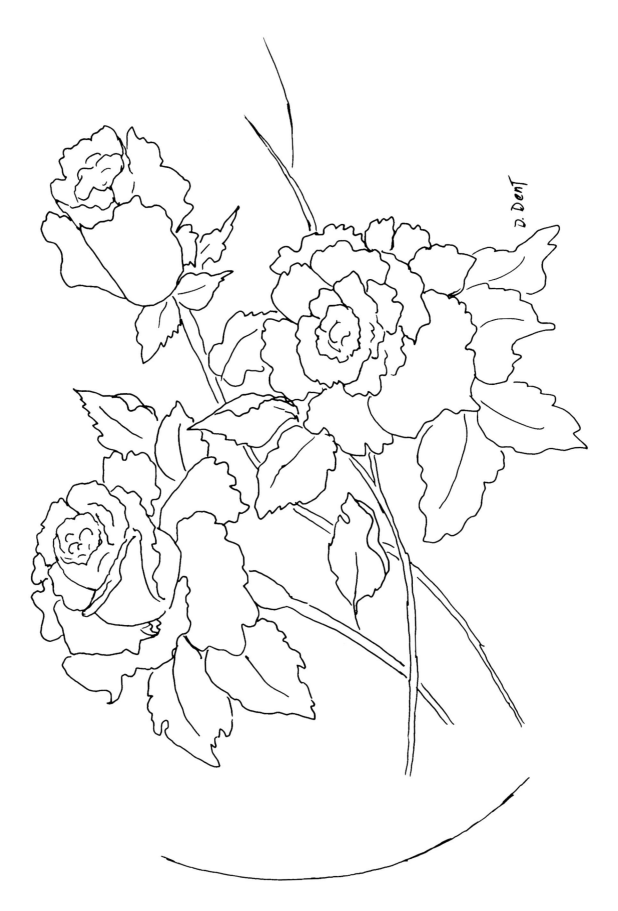

D. Dent

PATTERN

This pattern may be hand-traced or photocopied for personal use only.
Enlarge at 143 percent to bring up to full size.

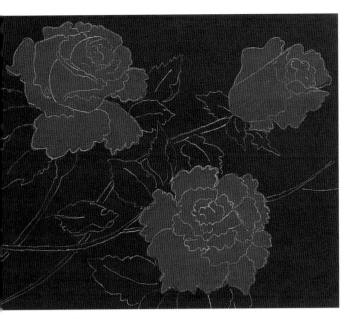

1 | BASECOAT SURFACES AND ROSES

Prepare the sewing box for painting as explained on page 14. Be sure you prepare all surfaces, inside and out. Basecoat the box top and bottom with two coats of Lamp Black, using a 1-inch (25mm) sponge brush. Paint the box edges, the inside of the box and the spool spindles with two coats of Leaf Green. Use a no. 8 flat for the spindles and box edges. Let dry. The spool spindles may be glued in place now or after the rose painting is done. Transfer the pattern with white graphite paper. Basecoat the roses in Napthol Red, using a no. 8 flat.

2 | PAT IN PETAL SHADING

For most of this project you'll use the no. 8 flat, but in some of the smaller rose petals, you may want to switch to a no. 4 flat. Corner load the brush with Deep Midnight Blue and apply shading to the petals of all the roses. Use short patting strokes, working across the petals. Shade in the deepest part of the petals or where one petal lies beneath another.

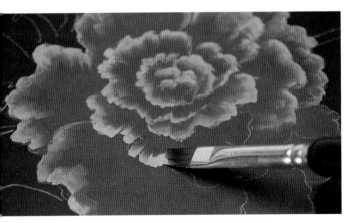

3 | HIGHLIGHT AND BLEND PETAL EDGES

Highlight the outside edges of the petals with Coral Rose. To do this, dip a brush corner in water and pat it lightly on a paper towel. Dip one corner of the brush in Coral Rose. Stroke the brush a few times on the palette to distribute the paint down the brush bristles. Using short, patting strokes, brush sideways across the petals with the Coral Rose to the outside. This should throw the Coral Rose to the outside edge of the petal. The damp brush will aid in blending the color into the middle or bottom of the petal. Since the paint can be rather transparent, some petals may need two or three coats to build up color.

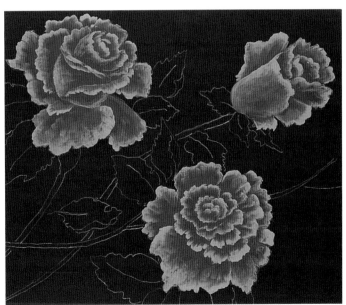

4 | FINISH CORAL ROSE HIGHLIGHTING

This view shows all the roses with the Coral Rose highlights.

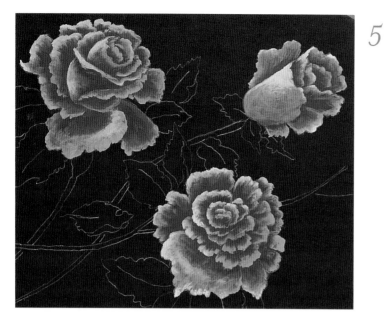

5 | HIGHLIGHT FURTHER, GLAZE AND TOUCH UP SHADING

Highlight as you did in step 3, but use Peaches 'n Cream. To help blend, you may want to sometimes pick up a little Coral Rose in the brush along with the Peaches 'n Cream. Glaze the roses very lightly with Napthol Red and then highlight again with Peaches 'n Cream. Add hints of Deep Midnight Blue + Light Buttermilk in a few shaded places where the contrast m need touching up.

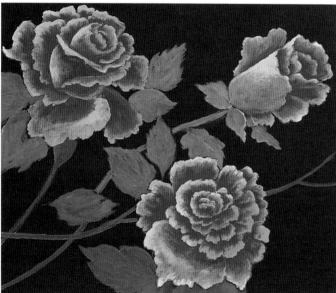

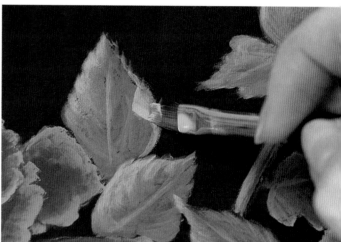

6 | BASE LEAVES AND STEMS

All leaf painting is done with a no. 8 flat; all stem painting with a no. 4 flat. Basecoat both leaves and stems with Leaf Green.

7 | ADD LEAF AND STEM HIGHLIGHTS

Highlight the leaves and stems with Hauser Light Green. On the leaves, stroke from the highlighted edge toward the vein while curving with the contour of the leaf. Paint a few curls on the leaf edges (see page 17). Continuing with the same color, paint the veins lightly with the chisel end of the brush. Further highlight with Hauser Light Green + Cadmium Yellow in the brightest areas.

tip Glazing is done with very thin paint. Begin with a little paint and a lot of medium or water. Add more paint as desired to build up the color a little at a time.

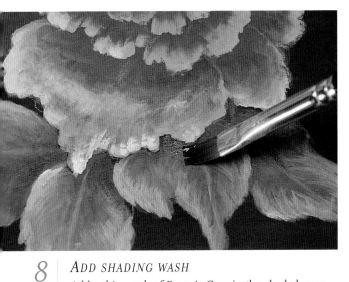

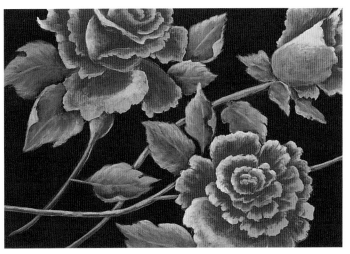

8 | *ADD SHADING WASH*
Add a thin wash of Payne's Grey in the shaded areas of the leaves.

9 | *ADD COLOR TOUCHES, SPOTS AND TINTS*
Add touches of Deep Midnight Blue + a bit of Light Buttermilk on some leaf edges. Paint in hints of brown leaf spots, using Sable Brown. Add touches of Napthol Red + a bit of Coral Rose for leaf tints.

10 | *FLICK OUT THORNS*
Flick out thorns with the tip of the no. 0 script liner and Hauser Light Green

We can complain because
rose bushes have thorns, or rejoice
because thorn bushes have roses.

Abraham Lincoln

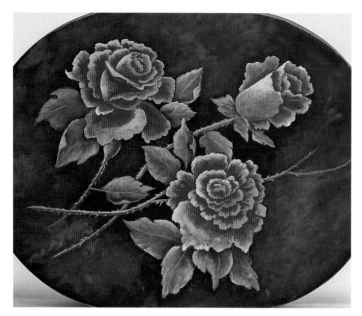

11 | ***SLIP-SLAP BACKGROUND COLOR***
With a very damp no. 8 flat, slip-slap some Napthol Red + a bit of Coral Rose into the background. Do the same here and there with Leaf Green. Keeping the paint wet gives you a soft look.

12 | ***PAINT SHADOW STEMS***
Add a few dark shadow stems with Payne's Grey and the chisel edge of a no. 8 flat.

13 | ***DETAIL LID AND VARNISH***
Use a no. 0 script liner to add a thin line of Coral Rose along the slanted edge around the top of the lid and the base. Let the painting dry completely and then spray with DecoArt Americana Acrylic Sealer/Finisher.

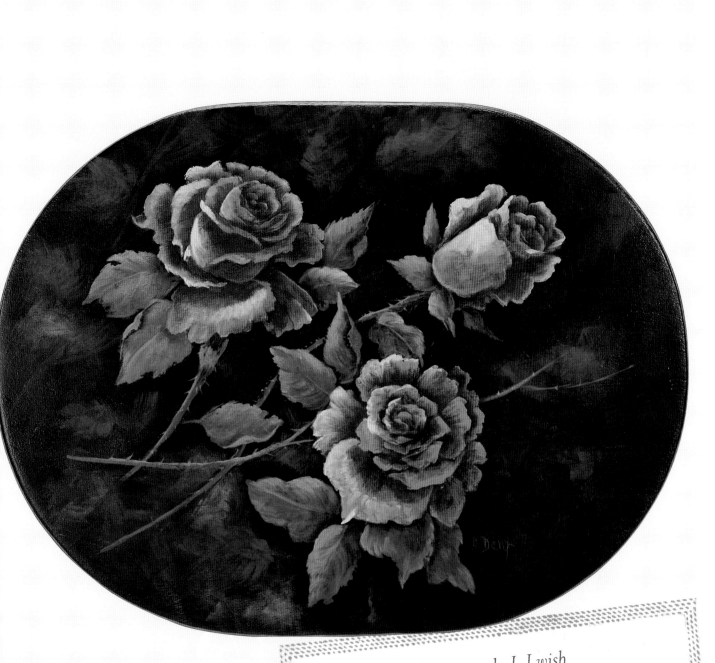

You love the roses—so do I. I wish
The sky would rain down roses, as they rain
From off the shaken bush...
They would fall as light
As feathers, smelling sweet; and it would be
Like sleeping and like waking, all at once!

George Eliot

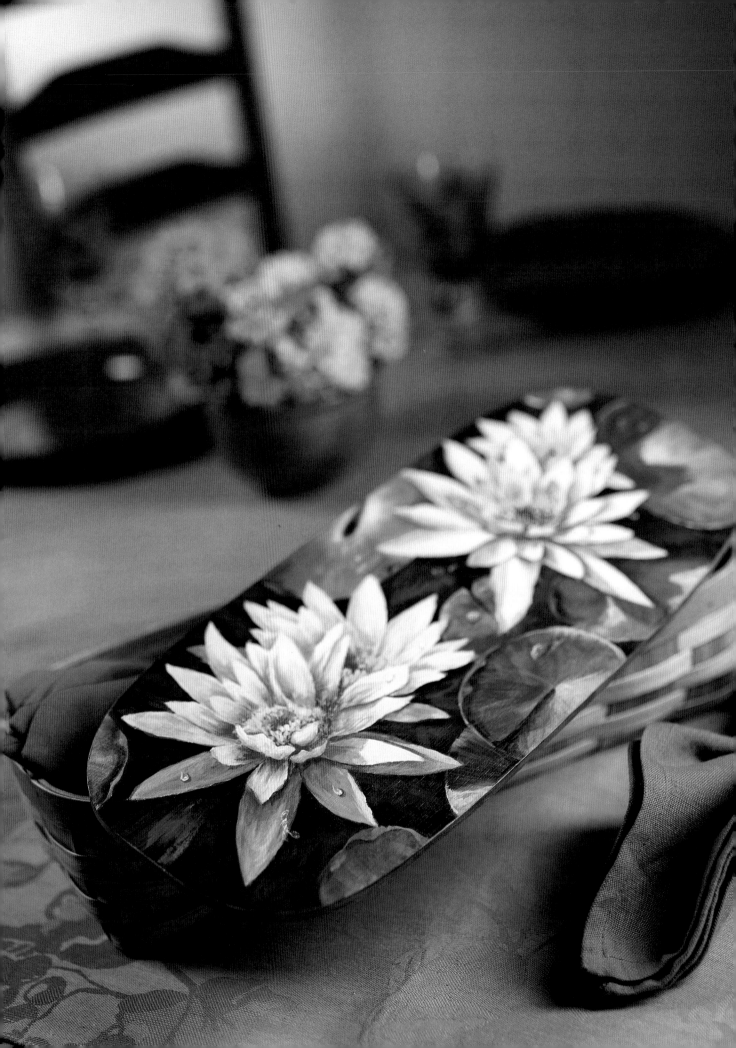

water lilies

I took the reference photo of these beautiful water lilies in my cousin's backyard garden. This painting is one of my personal favorites, and I hope you enjoy painting it as much as I did. It has quite a bit of detail and color layering, which create shadows and highlights. Remember to work for good contrast between petals so that each stands out.

COLORS

DecoArt Americana Acrylics

Antique Gold Baby Blue Black Forest Green

Blush Flesh Cadmium Red

Cadmium Yellow French Vanilla Hauser Light Green

Light Buttermilk Payne's Grey

Peaches 'n Cream Pineapple Russet

Spice Pink

SURFACE
• Oblong tabletop lidded basket, 6 ¾" × 16" (17cm × 41cm), #1A, from Pesky Bear

BRUSHES
• no. 8 flat
• no. 0 script liner
• 1-inch (25mm) sponge brush

ADDITIONAL SUPPLIES
• Sandpaper
• J.W. etc.'s Wood Sealer
• Tack cloth
• Black graphite paper
• Stylus, pen or pencil
• DecoArt Americana Acrylic Sealer/Finisher

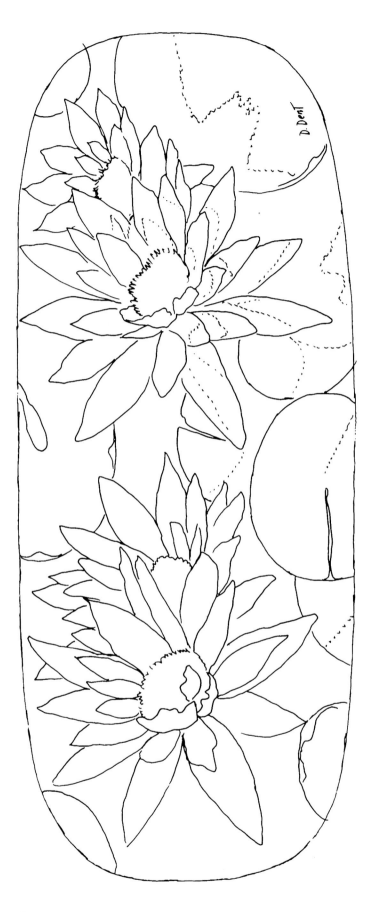

PATTERN

This pattern may be hand-traced or photocopied for personal use only.
Enlarge at 182 percent to bring up to full size.

1 | *BASE AND TRANSFER*
Prepare all surfaces of the basket lid as described on page 14. Basecoat the lid with Light Buttermilk, using a 1-inch (25mm) sponge brush. Transfer the pattern with black graphite paper. Basecoat the dark water around the leaves with two coats of Black Forest Green, using a no. 8 flat. You will also want to basecoat the bottom of the lid to keep it from warping.

2 | *FAN IN LIGHT–VALUE LEAF BASE*
Basecoat the light parts of the leaves with Hauser Light Green + a speck of Russet, working with a no. 8 flat. As you paint these leaves, fan your strokes from the center of the leaf outward.

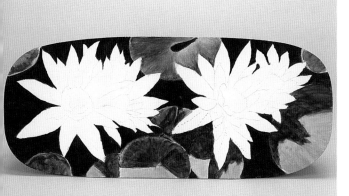

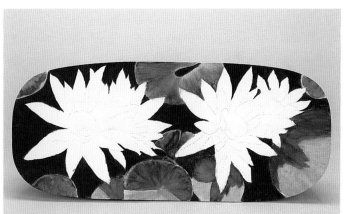

3 | *PAINT DARK–VALUE LEAF BASE*
With the same brush, paint the dark leaf area with two or three coats of Black Forest Green, occasionally picking up a touch of Russet. Fan your strokes from the center of the leaf outward, as you did with the light value.

4 | *HIGHLIGHT LEAF DARK–VALUE AREAS*
Continue with the same brush, loosely brushing over the dark leaf areas with thin Hauser Light Green + Black Forest Green. Occasionally add a touch of Russet. Continue to fan the colors in the direction they were laid in. These lighter colors will add highlights to the dark and will tie the light and dark areas together into one whole leaf.

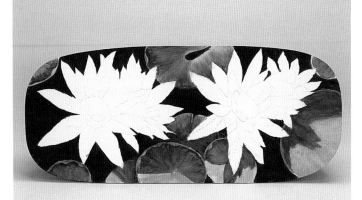

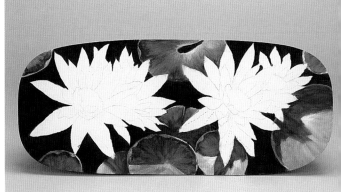

5 | *PAINT LEAF CURLS*
Paint the leaf curls using Payne's Grey as the shadow color beneath the curls (see page 17). Note where the leaves overlap and, where necessary, edge the upper leaf with more Hauser Light Green to delineate the outline.

6 | *HIGHLIGHT LEAVES*
Highlight the leaves with a light value of Pineapple + Hauser Light Green, using a no. 8 flat. Tap in the paint and fan it into the leaf. These light values right on the edge of the dark color really make the leaf shine.

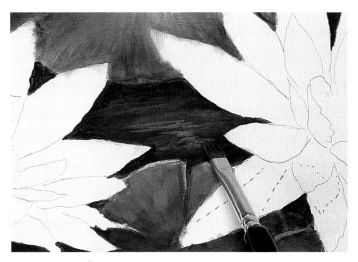

tip Be sure your brushes have a sharp chisel edge for all detail work on this project.

7 | *STROKE IN WATER HIGHLIGHTS*
With a no. 8 flat, add loose strokes of slightly moist Hauser Light Green + Black Forest Green in the dark water areas around the flowers. This makes the water look less flat.

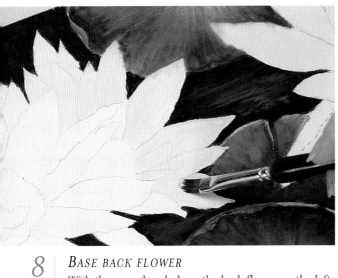

8 | *BASE BACK FLOWER*
With the same brush, base the back flower on the left with French Vanilla.

9 | *ADD DARKER–VALUE WASHES*
Corner load your no. 8 flat and add Antique Gold washes, working more to the bottom of the petals and sometimes up the sides. Stroke across the petals and let the Antique Gold fade as it goes into the length of the petal.

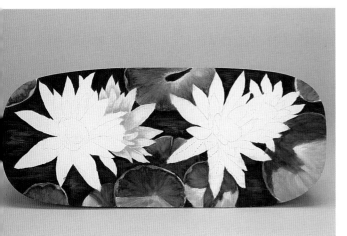

10 | *CONTINUE ADDING SHADING COLORS*
Continue with a no. 8 flat, adding touches of Peaches 'n Cream shading. Then add washes of Baby Blue + Blush Flesh for lavender pinks. Work to get light against dark as the petals overlap, painting the darker shading on the bottom petal.

Let us not…go hurrying about…
buzzing here and there…
But let us open our leaves
like a flower,
and be passive and receptive.

John Keats

tip Your colors do not have to match mine exactly. If your values and contrast are good, your painting will be good also.

11 | ***BASE FLOWER CENTER***
Base the flower center using the bottom corner of a no. 8 flat. Use Cadmium Red and Cadmium Red + Russet. Add a hint of Payne's Grey for the deepest area in the middle of the center and at the bottom between the adjoining flower petals.

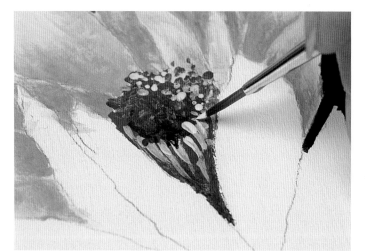

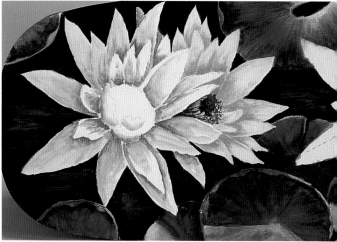

12 | ***ADD STAMENS***
Stroke in stamens with Cadmium Yellow + a touch of Antique Gold, using a no. 0 script liner.

13 | ***BASE THE PINK FLOWER***
Brush in pinks on the far left flower with Spice Pink Light Buttermilk. Use a corner-loaded no. 8 flat and stroke across the bottom of the petal, pulling the color into the petal's length.

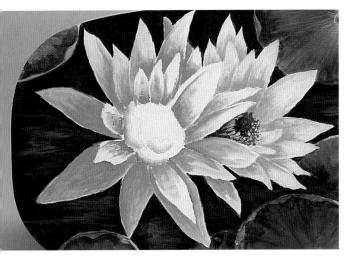

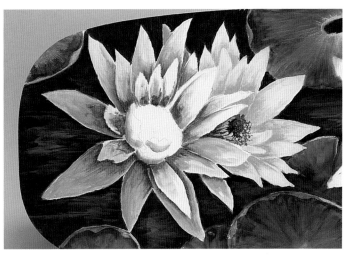

14 **SHADE THE PINK FLOWER**
Continue with a no. 8 flat, adding lavender shading with Baby Blue + Blush Flesh.

15 **ADD SHADING VALUES**
Still using a no. 8 flat, add deeper reds with Cadmium Red washes. Then paint the deepest shading with corner-loaded Payne's Grey, sometimes adding a bit of Cadmium Red.

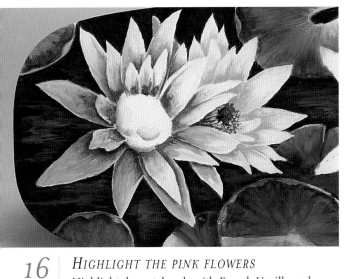

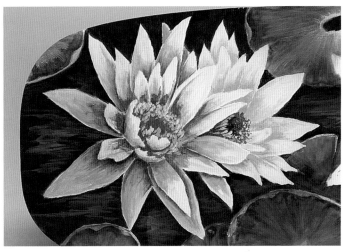

16 **HIGHLIGHT THE PINK FLOWERS**
Highlight the petal ends with French Vanilla and French Vanilla + Pineapple. Notice that the light source comes from the upper right, and place your highlights accordingly.

17 **PAINT FLOWER CENTER**
Paint the flower center in Cadmium Red, using the bottom corner of a no. 8 flat. Stroke in the stamens with Cadmium Yellow, using a no. 0 script liner.

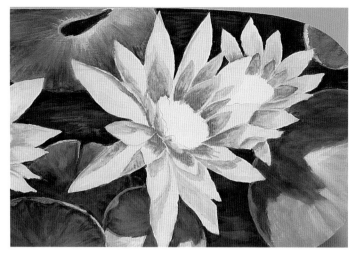

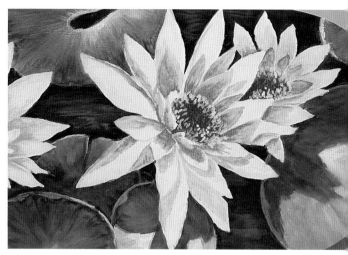

18 | *BASE AND SHADE RIGHT-HAND FLOWERS*
Go back to a no. 8 flat and base the petals of the flowers on the right with French Vanilla. Continue with a no. 8 flat and shade with Blush Flesh + a touch of Antique Gold. Place darker values at the bottom of the petals and where one petal lies behind another. Paint the inside petals of both flowers with a darker value of the shading color.

19 | *PAINT RIGHT-HAND FLOWER CENTERS*
Paint the flower centers with Cadmium Red and the bottom corner of a no. 8 flat. Stroke in Cadmium Yellow stamens using a no. 0 script liner.

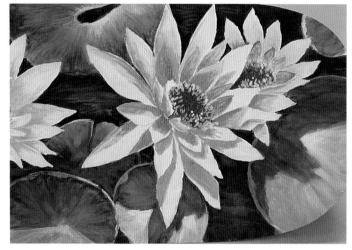

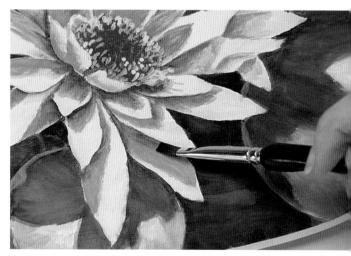

20 | *ADD MEDIUM SHADING VALUE*
Add shading of Baby Blue + Blush Flesh on the large right flower. Use a no. 8 flat.

21 | *ADD DARKEST SHADING VALUE*
Paint the deepest shadows with Payne's Grey.

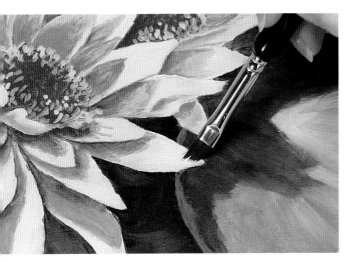

tip With acrylics you can quickly layer color on top of color many times. If you're unhappy with an area, just paint over it with the basecoat color and try again.

22 | *HIGHLIGHT PETALS AND DEFINE EDGES*
Add Light Buttermilk highlights on the petal ends of the same flower. Working with the same brush, use background colors to clean up the edges around the flowers as needed.

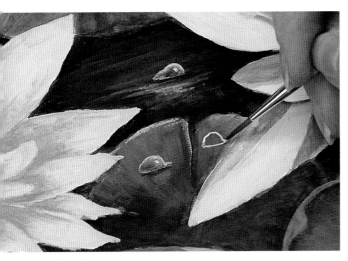

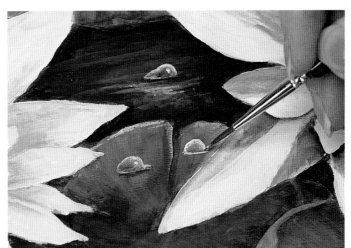

23 | *OUTLINE WATERDROPS*
Waterdrops are done entirely with a no. 0 script liner and Light Buttermilk. Scatter the droplets as you please. First outline the shape of the droplet. If the droplet is resting on a leaf or petal or the water, it will have a flat bottom.

24 | *FILL IN WATERDROPS*
While the paint is still wet, dilute the inside of the outline color with a moist brush to give the droplet a translucent look. Draw the paint and water from the top of the outline down. If the droplet appears too white, add some of the background color.

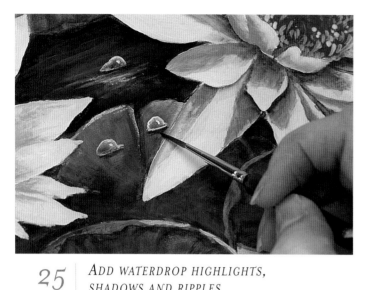

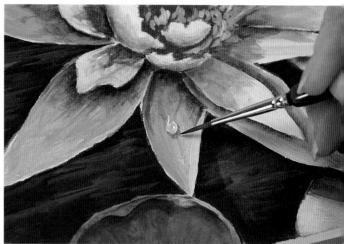

25 | ADD WATERDROP HIGHLIGHTS, SHADOWS AND RIPPLES
Dot in one or two highlights. Add a Payne's Grey shadow underneath. If the droplet is on the water, use the tip of the brush to stroke in Light Buttermilk ripples, as you see under the top droplet in this photo.

26 | PAINT TEAR–SHAPED WATERDROPS
Droplets that are about to drip are tear-shaped. Add the shadow following the tear shape.

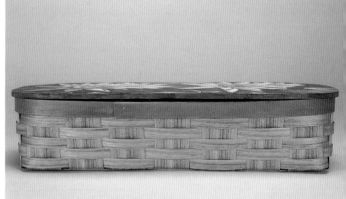

27 | EDGE THE LID
Paint the edge of the lid with two coats of Black Forest Green, using the no. 8 flat.

28 | EDGE AND TRIM THE BASKET
Brush slightly thinned Hauser Light Green and Blush Flesh + Baby Blue at random over the edge of the basket top. Paint the top strip of the basket with thinned Baby Blue + Blush Flesh loosely mixed for color variation.

Let the basket and lid dry completely and then spray both with DecoArt Americana Acrylic Sealer/Finisher.

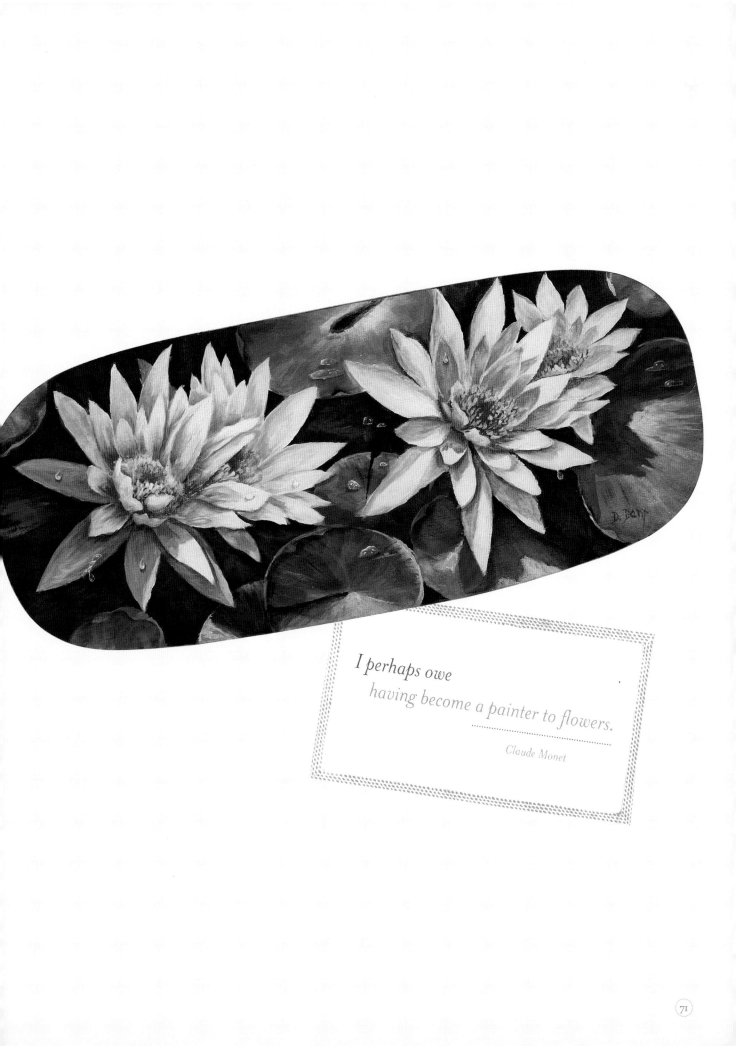

I perhaps owe
having become a painter to flowers.

Claude Monet

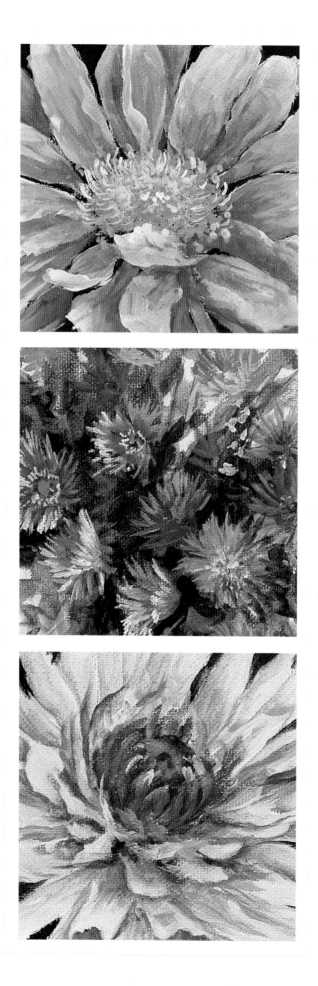

AUTUMN

If I were a bird
I would fly about the earth
seeking the successive autumns.

George Eliot

as summer fades, we come into another of my favorite seasons. Autumn flowers wait all summer for their turn to brighten our yards, and they give it their best until the first hard freeze.

We don't often think of pink for autumn flowers, but tall, graceful Japanese windflowers bobbing in the breeze are a lovely addition to an autumn garden. The windflowers in this book are easy to paint because they don't have many small areas on the petals.

Asters bloom in late summer and throughout autumn. Their cheery little blossoms are simple and old-fashioned. I love them—and I think you'll find painting them quick and fun.

Dahlias are great autumn bloomers. Their huge flowers make an impressive display, sometimes growing as large as dinner plates. This a not a difficult project. Just remember to create enough shading between the many petals, and they will separate nicely.

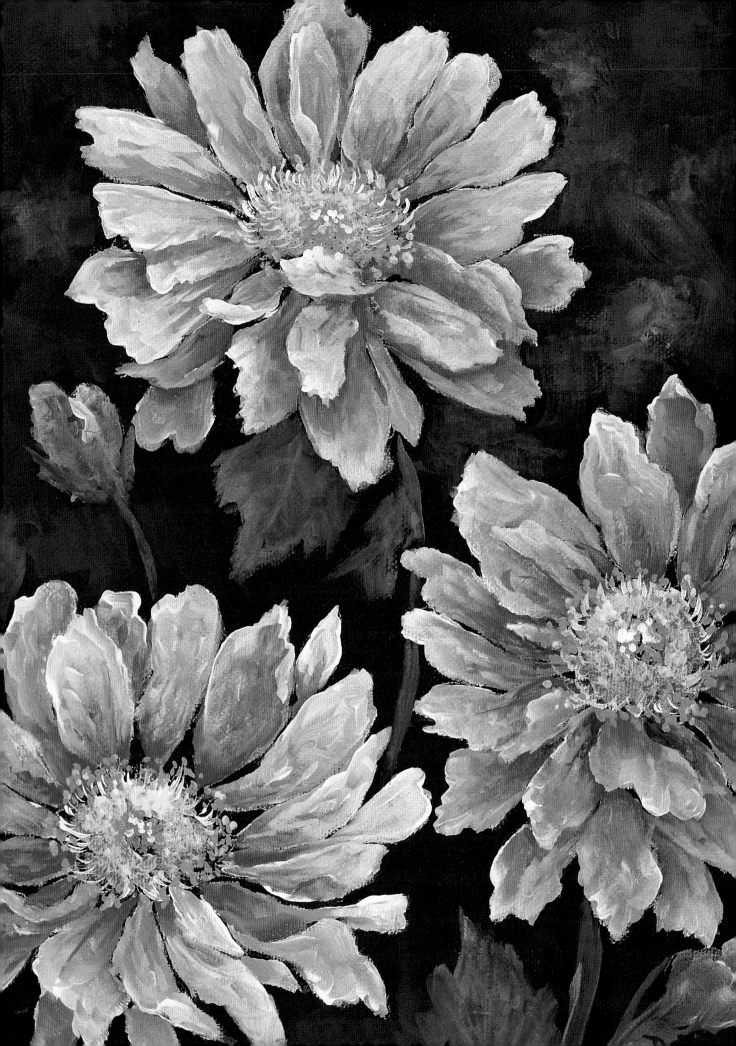

COLORS

DecoArt Americana Acrylics

Antique Gold Black Forest Green

Hauser Light Green Lemon Yellow

Orchid Royal Fuchsia

Titanium White

japanese windflowers

Tall, graceful Japanese windflowers can grow 3 to 5 feet (.9m to 1.5m) or more. As they dip and nod their 4-inch (10cm) blossoms in the wind, they prove the appropriateness of their name. Notice that the background of this painting is loosely stroked in with various greens and touches of pink that tie into the flower colors. This background technique works well with many florals and still lifes.

SURFACE
• Stretched canvas, 12" × 9" (31cm × 23cm) canvas

BRUSHES
• no. 8 flat
• no. 0 script liner
• 1-inch (25mm) sponge brush

ADDITIONAL SUPPLIES
• Gesso
• White graphite paper
• Stylus, pen or pencil
• DecoArt Easy Float
• DecoArt Americana Acrylic Sealer/Finisher

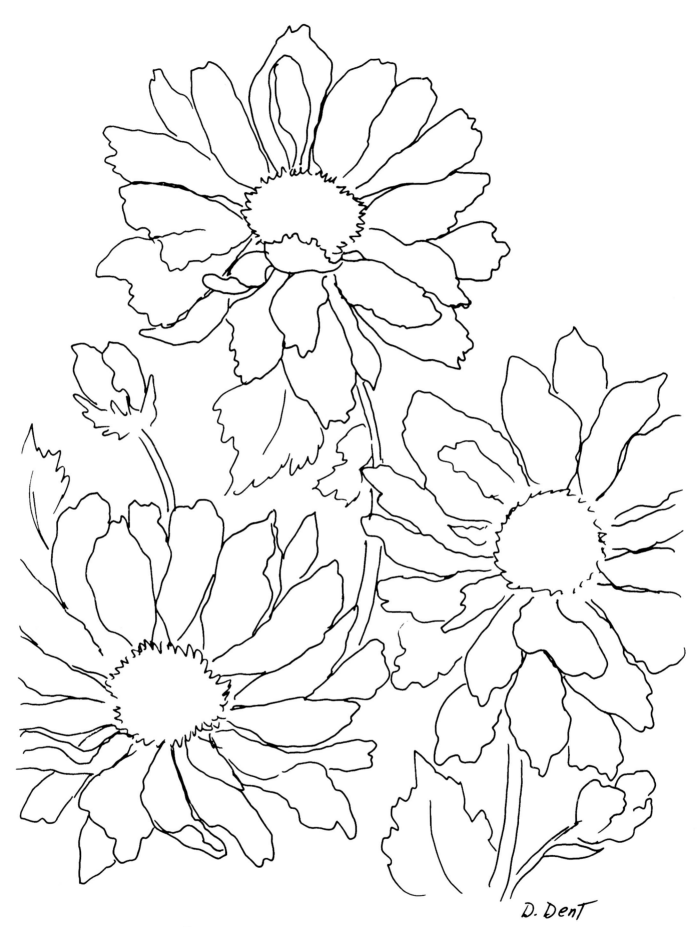

D. Dent

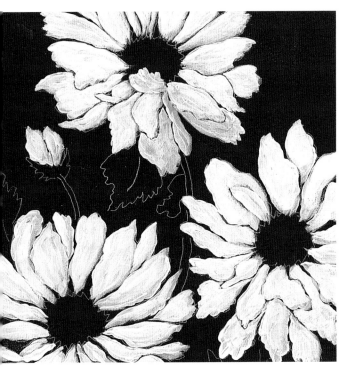

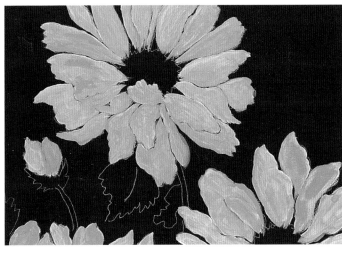

2 | ADD PETAL COLOR
Using the same brush, paint over each petal with a brush mix of Orchid + Titanium White.

1 | BASE AND TRANSFER
Prepare the canvas as described on page 14. Base with two coats of Black Forest Green, using a 1-inch (25mm) sponge brush. Transfer the pattern with white graphite paper. With the no. 8 flat, basecoat the petals with Titanium White. Leave a tiny line between the petals at the tracing lines.

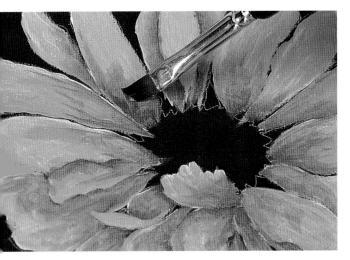

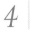

3 | SHADE PETALS
Shade at the base of the petals with Royal Fuchsia corner-loaded on a no. 8 flat. Keep the paint moist and blend into the lighter pink, working across the petals. Also shade the undermost of overlapping petals.

4 | DEEPEN SHADING
Continuing with a no. 8 flat, add a little depth to the shading with a brush mix of Royal Fuchsia + a bit of Black Forest Green. Avoid completely covering the Royal Fuchsia shading.

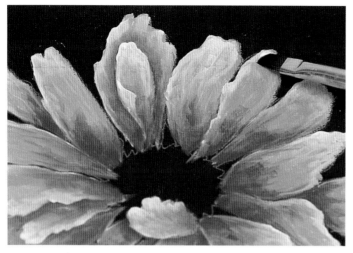

5 | HIGHLIGHT PETALS AND CURL EDGES

Highlight the petal edges as desired with Titanium White. Paint with a corner-loaded no. 8 flat, using the damp, paintless corner of the brush to blend. Highlight the uppermost of overlapping petals and add some petal curls with the shading color on the corner of the brush (see page 17).

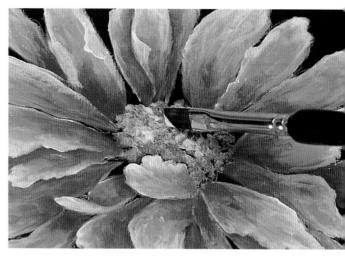

6 | DAB IN FLOWER CENTERS

With the bottom corner of your no. 8 flat, dab Lemon Yellow in the flower centers. Leave the top edges uneven. Let dry and then dab on another coat.

tip Look for the growth direction of petals and leaves. Move the paint to conform to the growth direction of vein lines.

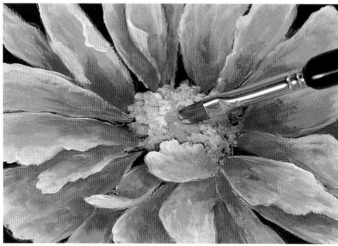

7 | ADD COLOR TO CENTER

Let the Lemon Yellow dry and then dab Hauser Light Green in the middle of the flower centers, again using the bottom corner of the brush.

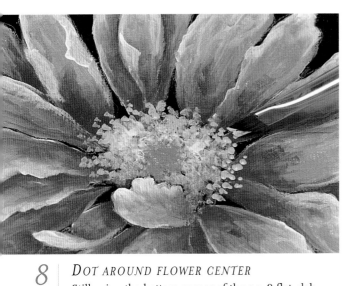

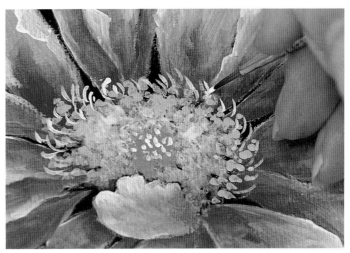

8 | *DOT AROUND FLOWER CENTER*
Still using the bottom corner of the no. 8 flat, dab Antique Gold dots around the outside edges of the flower centers. Keep the edges uneven.

9 | *DOT INSIDE CENTER AND ADD STAMENS*
With Titanium White on a no. 0 script liner, add white dots to the very centers of the flowers. Then paint comma-stroke stamens on the upper edges of the flower centers. Make the curve of the commas follow the curve of the flower centers.

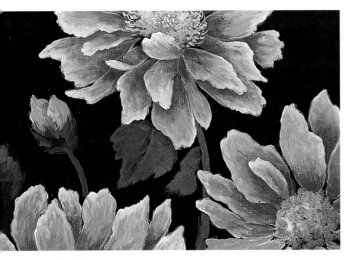

10 | *BASE STEMS, LEAVES AND BUDS*
With a brush mix of Hauser Light Green + Black Forest Green + a touch of Royal Fuchsia, base the stems, leaves and bud sepals using a no. 8 flat. Add a second coat as needed.

11 | *ADD HIGHLIGHTS AND PAINT LEAF VEINS*
Highlight the stems, leaves and buds with a brush mix of Hauser Light Green + Black Forest Green on a no. 8 flat. Paint light leaf veins with the chisel edge of the brush.

tip When painting leaves, always add a touch of the flower color. This ties flowers and leaves together and gives the painting a more pleasing look.

12 | *TINT LEAVES*
With the same brush, add touches of Royal Fuchsia to the stems, leaves and sepals..

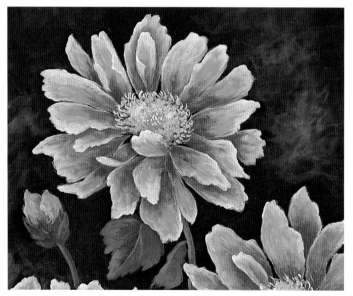

13 | *SLIP-SLAP BACKGROUND COLOR*
Brush-mix Hauser Light Green + Black Forest Green + Easy Float and slip-slap the color into the background, using a no. 8 flat. Apply most of this color to the upper half of the painting.

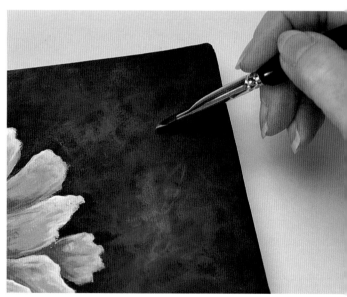

14 | *FINISH BACKGROUND COLOR AND VARNISH*
Continue the slip-slap strokes with touches of Royal Fuchsia. Allow the painting to dry completely, and then spray with DeocArt Americana Acrylic Sealer/Finisher.

He who is born with a silver spoon
 in his mouth is generally considered a fortunate
 person, but his good fortune is small compared
 to that of the happy mortal who enters this
 world with a passion for flowers in his soul.

Celia Thaxter

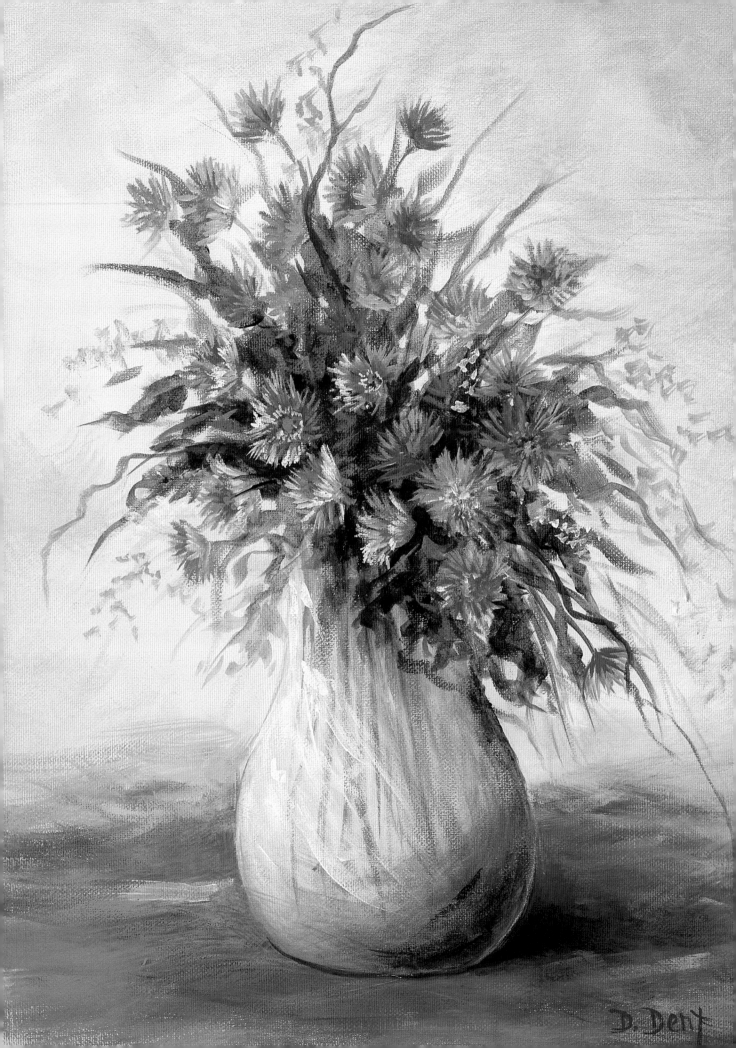

asters

This little bouquet of asters is a fun project, and it gives you an opportunity to paint a simple vase along with the floral arrangement. The leaves and flowers should be painted loosely. To help you do so, I provided only minimal pattern lines for these elements. In fact, this project is good practice for painters who have trouble loosening up.

COLORS

DecoArt Americana Acrylics

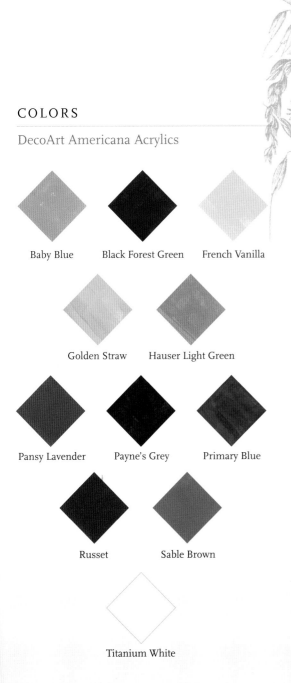

Baby Blue

Black Forest Green

French Vanilla

Golden Straw

Hauser Light Green

Pansy Lavender

Payne's Grey

Primary Blue

Russet

Sable Brown

Titanium White

SURFACE
• Stretched canvas, 16" × 12" (41cm × 31cm)

BRUSHES
• no. 8 flat
• no. 16 flat
• no. 0 script liner
• 1-inch (25mm) sponge brush

ADDITIONAL SUPPLIES
• Gesso
• Black and white graphite paper
• Stylus, pen or pencil
• DecoArt Easy Float
• DecoArt Americana Acrylic Sealer/Finisher

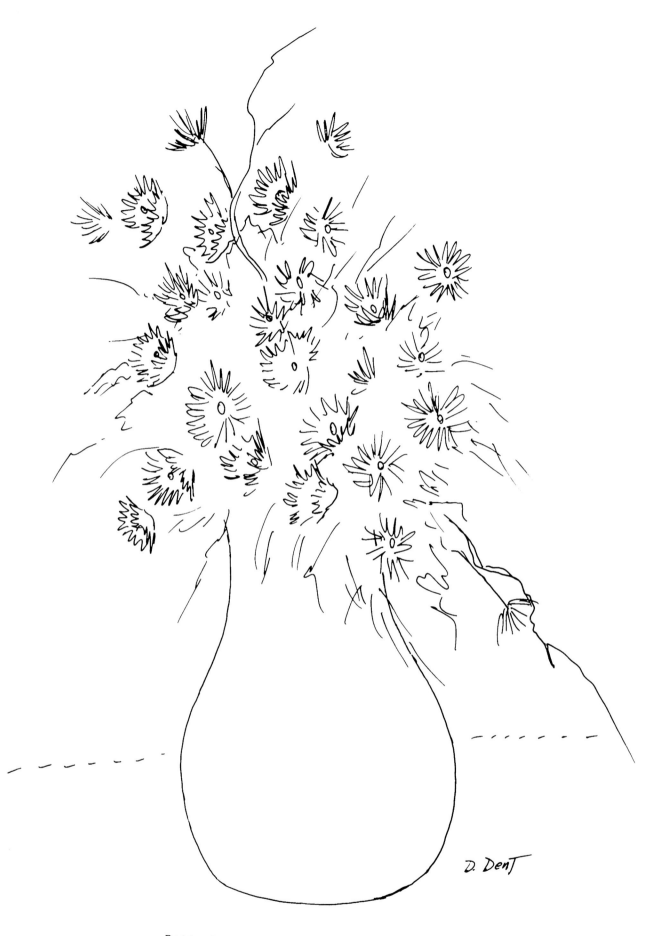

PATTERN

This pattern may be hand-traced or photocopied for personal use only.
Enlarge at 147 percent to bring up to full size.

1 | **B**ASE, *TRANSFER AND PAINT THE FOLIAGE*
Prepare the canvas as explained on page 14. Basecoat with two coats of French Vanilla using a 1-inch (25mm) sponge brush. Transfer the pattern with black graphite paper.

Paint the foliage with a no. 8 flat, using a loose brush mix of Black Forest Green + Russet. Make your brush go in all directions. The flower pattern lines give you a sense of composition, but you will paint over most of them. Work for an interesting leafy effect on the outside edge. You'll need two coats on the inner part of the bouquet to make a nice dark background.

Once you finish painting the foliage, transfer the parts of the flower pattern that have been covered with paint. Use white graphite paper so the lines will show against the dark foliage.

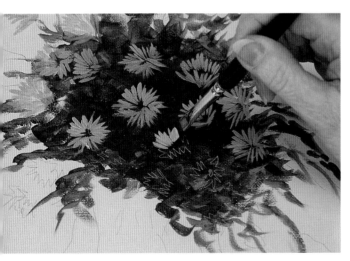

2 | **S**TROKE IN ASTERS
Using the pattern lines as a loose guide, stroke in the asters with Baby Blue, painting with the chisel edge of a no. 8 flat.

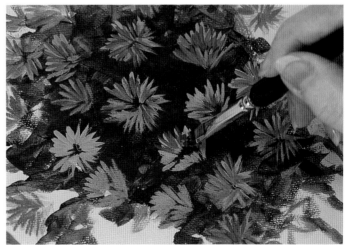

3 | **D**EEPEN COLOR
With the same brush, stroke Primary Blue on the petals to deepen the color. Don't cover the Baby Blue completely. If you get too much Primary Blue, you can reapply some Baby Blue or mix the two blues on your brush.

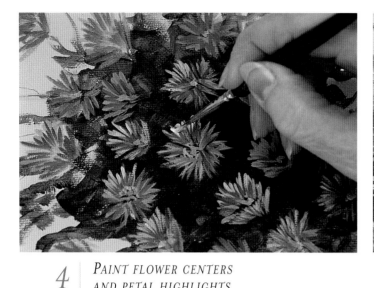

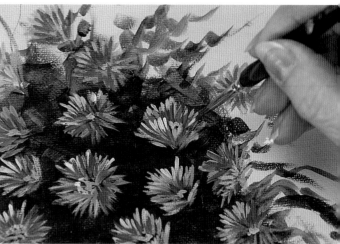

4 *PAINT FLOWER CENTERS AND PETAL HIGHLIGHTS*

Put a bit of Golden Straw on the tip of a no. 0 script liner and dab centers into the flowers. Use the script liner to highlight some of the petals with light strokes of Titanium White. Stroke from the end of the petal toward the center. On some of the flowers, touch in a little fringe of white around the yellow centers.

5 *ADD TO PETAL COLORS*

Still using the script liner, add touches of Pansy Lavender on the petals here and there. Stroke from the outside toward the flower center.

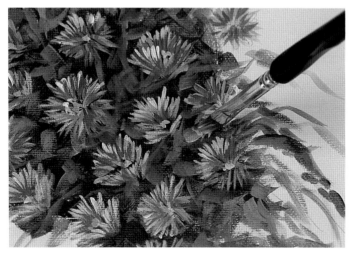

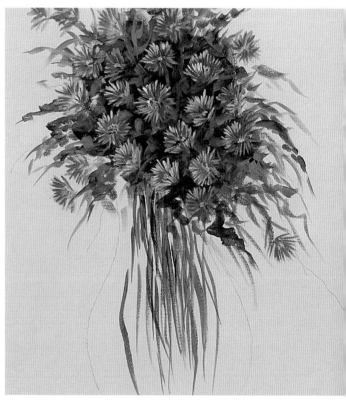

6 *LIGHTEN THE FOLIAGE*

Using a no. 8 flat, brush in some lighter foliage with Hauser Light Green and Hauser Light Green + a bit of Black Forest Green. Avoid losing all your dark foliage. If you feel you've lightened too much, deepen a few places with Black Forest Green + Russet. Go for a loose leafy look with varied color values.

7 *PULL STEMS*

With Black Forest Green + Russet, pull stems into the vase area with the chisel edge of a no. 8 flat.

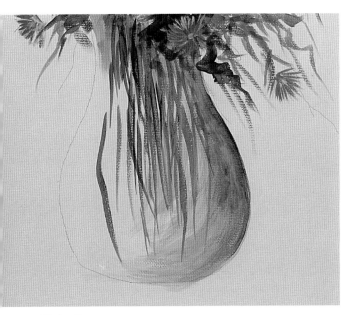

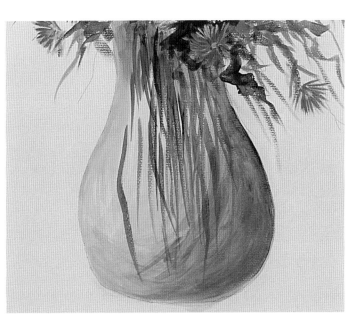

8 *BEGIN VASE REFLECTION COLORS*
Using a no. 8 flat, add thinned Black Forest Green at the top and right side of the vase. Follow the contour of the vase with your strokes, thinning the paint with water as you brush to the inside. On the right side of the vase, apply a darker value of the Black Forest Green.

9 *ADD MORE REFLECTION COLORS*
Add a thin brush mix of Baby Blue + Primary Blue on the sides and bottom of the vase. Vary the proportions of the blues, overlapping the Black Forest Green a bit where the colors meet.

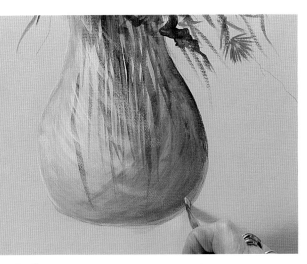

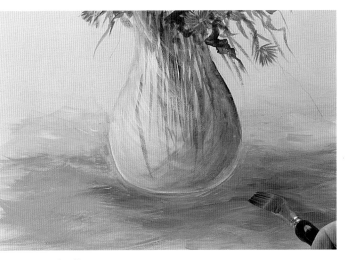

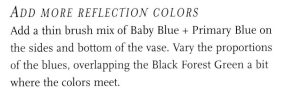

10 *STREAK IN REFLECTED LIGHT*
Streak Titanium White on the right edge of the vase and pull it into the vase with the flat of the brush. Put in several layers of strokes, but keep the streaky look. Brush in a streak of reflected light on the bottom right of the vase.

11 *BRUSH IN TABLE SURFACE*
Brush random back-and-forth strokes of Baby Blue and Baby Blue + Primary Blue on the table with a no. 16 flat. Be sure you use enough water to keep the paint moist. As you move to the far edge of the table, work in more water so the color fades into the background. To aid the blending into the background, pick up a little French Vanilla with the blues still on the brush.

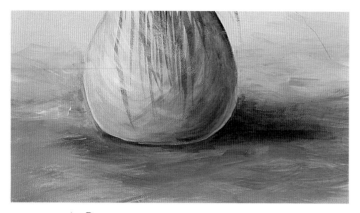

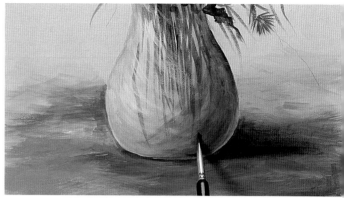

12 *PAINT SHADOW AND HIGHLIGHT*
With a no. 8 flat, shade the lower right of the vase with a little thinned Payne's Grey. Then add the vase shadow with a darker value of Payne's Grey. Paint a dark shadow under the vase with the same color. Stroke a Titanium White highlight on the table to the right of the vase.

13 *TINT VASE AND TABLE*
Paint a few quick strokes of Sable Brown around the vase to add some warmth. Add a little Black Forest Green in the bottom right corner of the vase with a no. 8 flat. Add a few strokes of Sable Brown also in the bottom right corner of the vase. Adjust colors as desired.

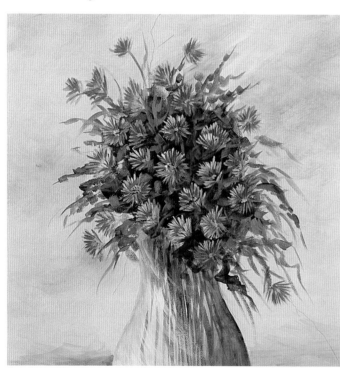

14 *WASH IN BACKGROUND COLOR*
With a no. 16 flat, slip-slap wet Sable Brown over the French Vanilla background. You may want to add a little Easy Float to the paint to thin it and allow it to brush in easily. Keep the top third darkest with the very darkest values in the top right. Paint loosely in all directions, letting the strokes show.

15 *FILL IN BOUQUET AND VARNISH*
Paint in twigs with Russet + Sable Brown. Make wiggly lines using the side of a no. 8 flat. Add a few light touches of the brown mix in the foliage. At this point review the composition and extend more leaves or flowers into the background if you feel they need to be there. Paint the leaves Hauser Light Green or Hauser Light Green + Black Forest Green. Paint the flowers Baby Blue. Add extra highlighting to the petals of the middle flowers with Titanium White on the no. 0 script liner.

Let the painting dry completely and then spray with DecoArt Americana Acrylic Sealer/Finisher.

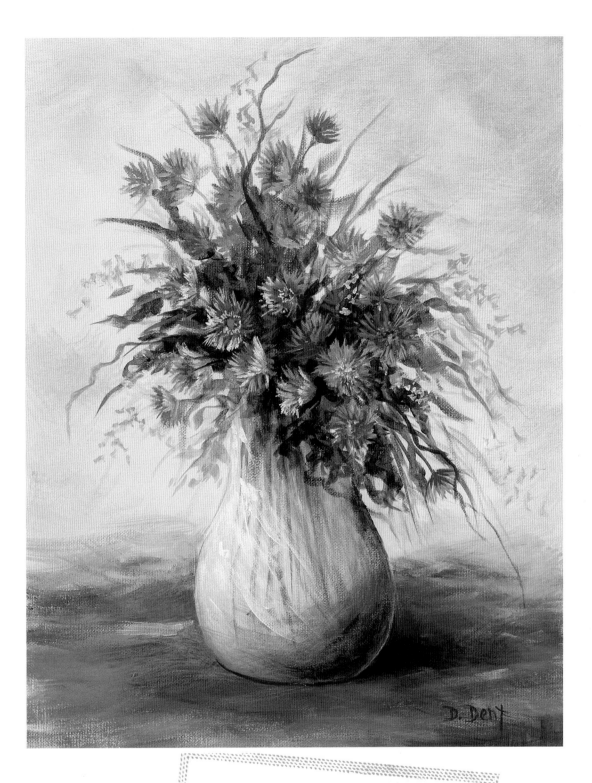

It is not how much we have,
but how much we enjoy,
that makes happiness.

Charles Haddon Spurgeon

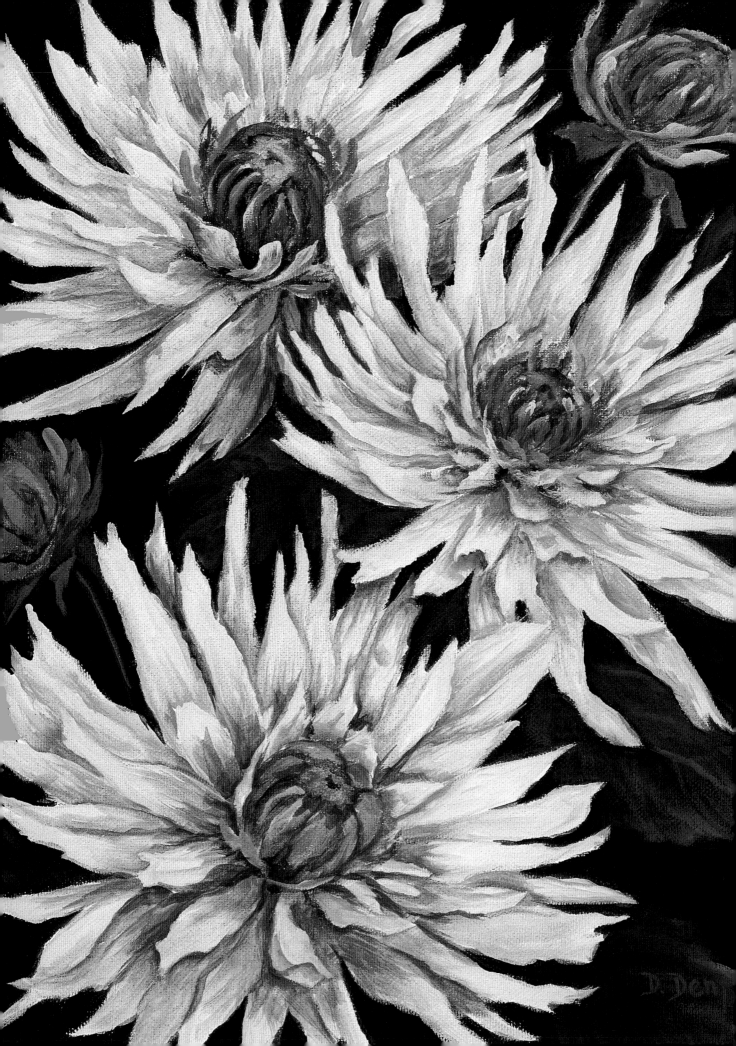

cactus dahlias

Dahlia flower heads are so huge, they tend to fall over with their own weight. My own did quite well one summer until I left town to teach a seminar. By the time I came home, they had fallen to the ground as I hadn't taken the time to stake them. However, I managed to get them propped up (sort-of), and they carried on with their beautiful display a while longer. When painting these dahlias, note the curved strokes in the center area, which build the loose ball shape.

COLORS

DecoArt Americana Acrylics

Antique Gold Black Forest Green

Cadmium Red French Vanilla Hauser Light Green

Payne's Grey Russet

SURFACE
• Stretched canvas, 14" × 11" (36cm × 28cm)

BRUSHES
• no. 8 flat
• 1-inch (25mm) sponge brush

ADDITIONAL SUPPLIES
• Gesso
• Black graphite paper
• Stylus, pen or pencil
• DecoArt Americana Acrylic Sealer/Finisher

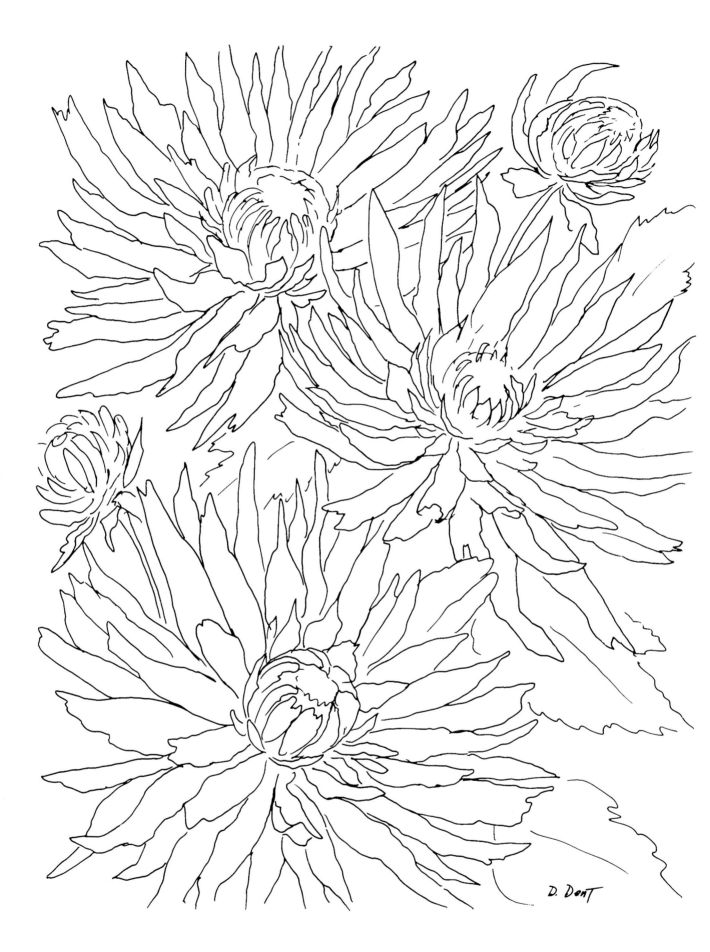

D. Dont

PATTERN

This pattern may be hand-traced or photocopied for personal use only.
Enlarge at 154 percent to bring up to full size.

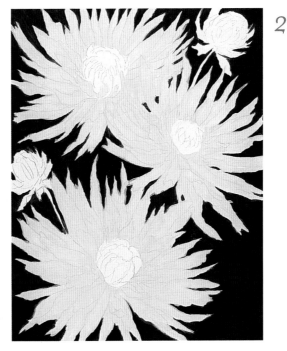

2 | **BASE PETALS**

Basecoat the petals with one coat of French Vanilla. Your pattern lines should be dark enough to allow you to paint right over them. Avoid painting the flower centers.

1 | **BASE AND TRANSFER**

Prepare the canvas as explained on page 14, using three coats of gesso. Transfer the pattern with black graphite paper, making the lines dark enough to show through one coat of French Vanilla, which will be applied next. From this point, all painting is done with a no. 8 flat. Paint the background around the flowers with two coats of loosely mixed Black Forest Green + Russet. Sometimes allow more Russet to show; sometimes more Black Forest Green.

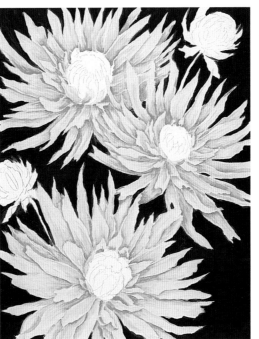

3 | **SHADE PETALS**

To help delineate the petals, shade with corner-loaded Antique Gold at the base of the petals and between petals that are lying on top of or next to each other. Make the shading darkest at the base of the petals and lighter with thinner paint as you work out.

Let fortune's bubbles rise and fall;
Who sows a field, or trains a flower,
Or plants a tree is more than all.

John Greenleaf Whittier

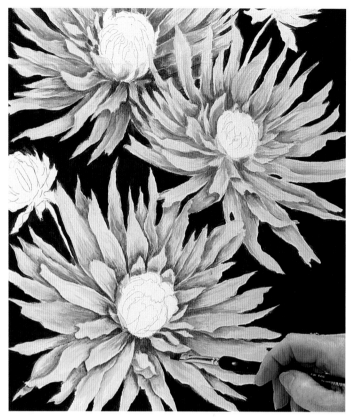

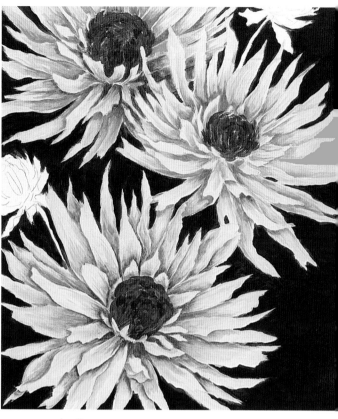

4 | *DEEPEN SHADING*
Add touches of thinned corner-loaded Cadmium Red + Russet for deeper shading on some of the petals. This will continue to separate the petals and add depth. Add more shading to the bottom flower to help bring it forward.

5 | *BASE CONTOURED FLOWER CENTERS*
Basecoat the flower centers with Cadmium Red + Russet, following the rounded contour. Coverage should not be solid, and a variety of light and dark strokes helps create form.

tip If you have problems covering a tracing line, just stroke more paint on it.

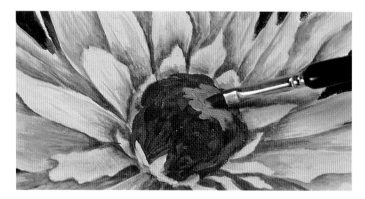

6 | *ADD COLOR TO CENTERS*
Add Hauser Light Green in the middle of the flower centers where the petals come together.

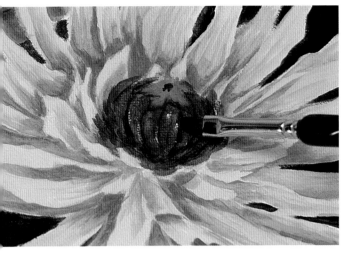

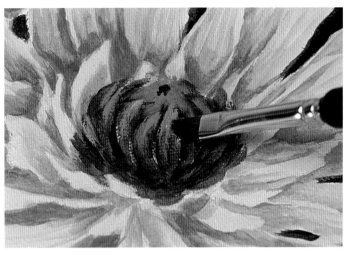

7 *DEEPEN SHADING OF CENTERS*
Add a jagged line of darker shading around the green with corner-loaded Payne's Grey. Also dot a bit of this color in the center of the green. Then create petal separation with Payne's Grey on the chisel edge of the brush and add some shading at the base of the flower center.

8 *HIGHLIGHT CENTERS*
Add highlights to the flower centers with Antique Gold and French Vanilla.

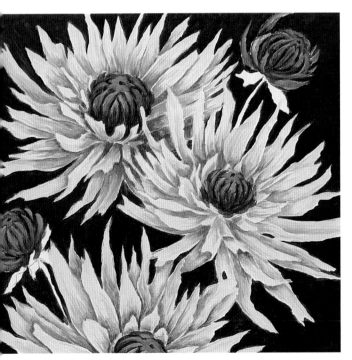

9 *PAINT BUDS*
Paint the buds in the same manner as the flower centers (steps 5 through 8) but a bit more loosely.

> *Flowers…are a proud assertion that a ray of beauty outvalues all the utilities of the world.*
>
> Ralph Waldo Emerson

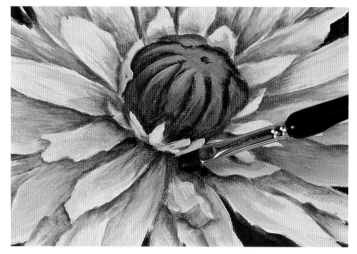

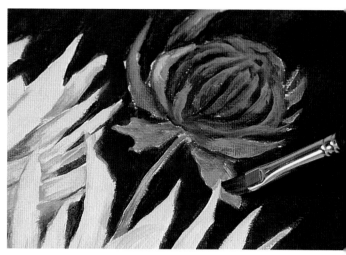

10 | *DEEPEN CENTRAL PETAL SHADING*
Add deeper shading to the large petals beneath and to the left of the flower centers. Use Payne's Grey + Black Forest Green, sometimes adding a bit of Russet, on a corner-loaded brush. Place the shading at the base of the petals and beneath overlapping petals.

11 | *PAINT SEPALS AND STEMS*
Paint the bud sepals and stems with Hauser Light Green + Payne's Grey.

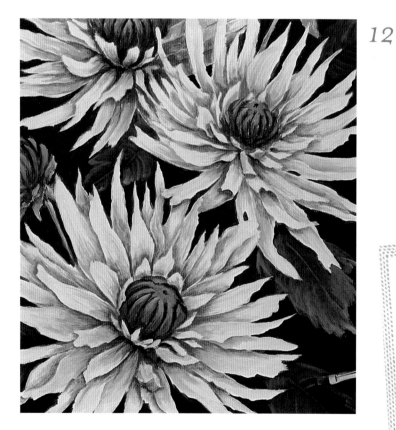

12 | *ADD LEAVES AND VARNISH*
In the open background spaces, add suggestions of large leaves with Hauser Light Green + Payne's Grey, using loose strokes. First, loosely outline the leaf and draw a center vein. Then fill in with strokes drawn from the leaf vein and outward. Add Antique Gold to the leaf edges for a little highlight.

Let the painting dry completely and then spray with DecoArt Americana Acrylic Sealer/Finisher.

In all things of nature
there is something of the marvelous.

Aristotle

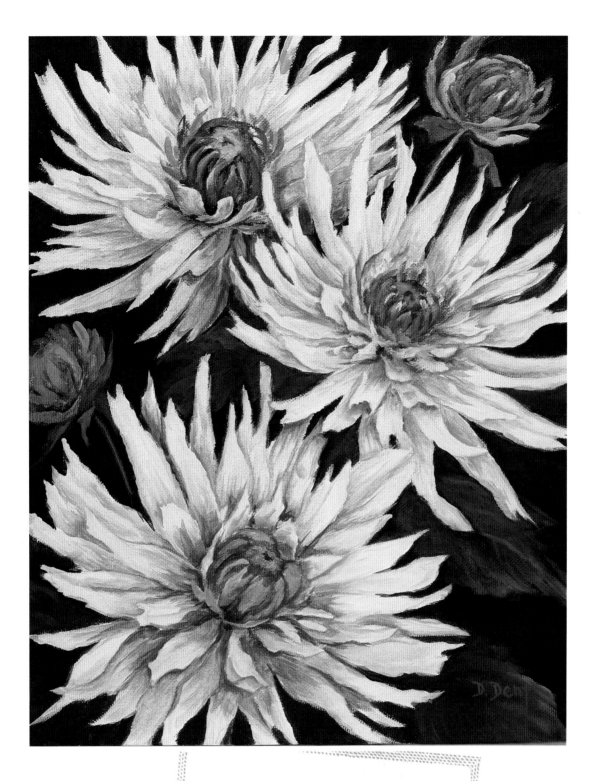

Beauty is God's handwriting.

Charles Kingsley

WINTER

Winter here
hath gladsome gardens of his own.

Dorothy Wordsworth

winter is a time of true rest for our yards and gardens. Annuals die off, perhaps reseeding, and perennials go underground to gather their strength for spring.

But a few hardy flowers, such as chrysanthemums, hang on through the early days of winter. The mums in this book aren't difficult to paint. They're similar to the asters in the looseness of the foliage and in the manner in which the flowers are painted.

Paper-white narcissus is a lovely indoor plant that helps us through the more severe winter months. This is another rather simple project. Note the "flip-flop" background strokes, which are a bit different from a flat-painted background.

I thought of including poinsettias, but they have been "done to death" in painting books, so I decided to offer another red potted plant to round out the winter selection. The amaryllis comes in a number of colors and varieties. After painting this project, you might want to try a variation, using a photo or an amaryllis of your own for reference. As a painter, you can create a garden of your favorite flowers in your preferred colors all year long.

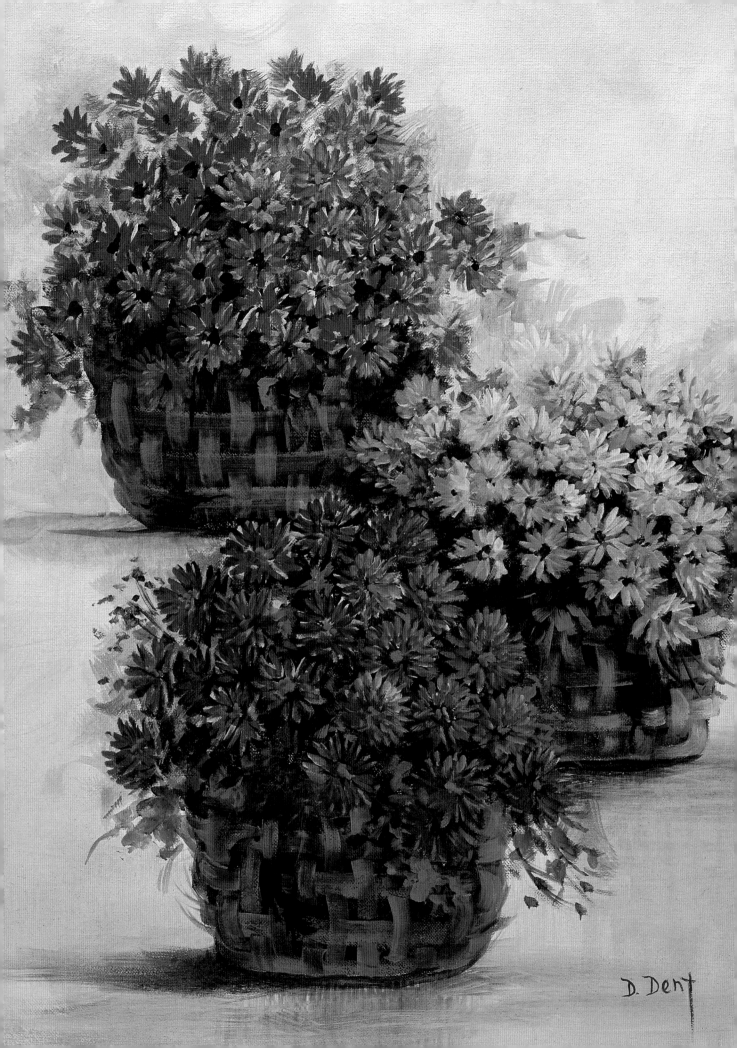

D. Dent

chrysanthemums

We usually think of "mums" in relation to autumn, and indeed they are in their glory at that time of the year. However, they often go into early winter, and they are some of the last garden flowers to give in to Jack Frost. In honor of their hardiness, I include them among the winter flowers. As you're painting, you may want to add more blossoms to those designated on the pattern—just go for a balanced look. This project also teaches "basket weaving," which you're likely to find useful for other paintings.

COLORS

DecoArt Americana Acrylics

Antique Gold Black Forest Green

Black Plum Burnt Orange

Crimson Tide Hauser Light Green

Lemon Yellow Light Buttermilk

SURFACE
• Stretched canvas, 18" × 14" (46cm × 36cm)

BRUSHES
• no. 8 flat
• no. 16 flat
• 1-inch (25mm) sponge brush

ADDITIONAL SUPPLIES
• Gesso
• Black and white graphite paper
• Stylus, pen or pencil
• DecoArt Americana Acrylic Sealer/Finisher

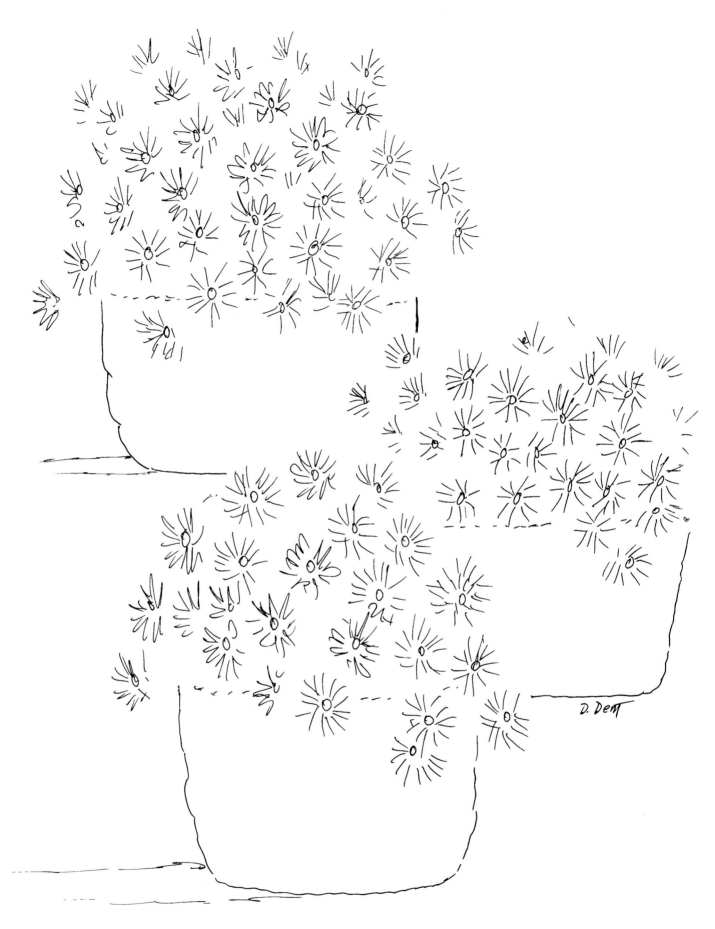

D. Dent

PATTERN

This pattern may be hand-traced or photocopied for personal
use only. Enlarge at 167 percent to bring up to full size.

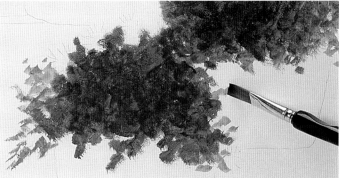

2 ADD LIGHT BACKGROUND FOLIAGE
Using a no. 16 flat, brush some very thin Black Forest Green into the background around the foliage with loose strokes going various directions.

1 BASE AND TRANSFER
Prepare the canvas as explained on page 14. Basecoat with two or three coats of Light Buttermilk, using a 1-inch (25mm) sponge brush. Transfer the pattern with black graphite paper and a stylus or pen. For the flowers you need transfer only the outside edges to use as a guide for the greenery. Block in the greenery with Black Forest Green, sometimes adding touches of Light Buttermilk with the green. Pounce in the color with the corner of a no. 16 flat. Paint the outside edges of the foliage with very moist Black Forest Green for a lighter look. The inner foliage should be very dark, so you'll need two or three coats of Black Forest Green.

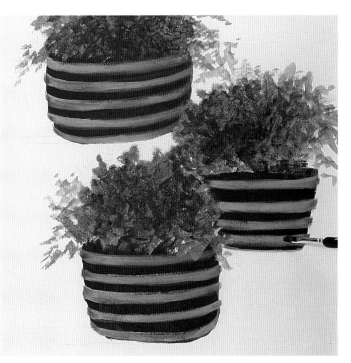

4 PAINT HORIZONTAL BANDS
Using a no. 8 flat, stroke bands of Antique Gold across the baskets. Drag your strokes a bit beyond the outside edges of the baskets and curve the strokes slightly to follow the baskets' rounded contours. You'll probably need to stroke each band two or three times to get good color, but don't try to make the paint opaque or to create crisp edges. Where the bands extend beyond the basket, touch in a bit of Black Plum to give the ends definition.

3 BASE BASKETS
With the same brush, basecoat the baskets with two coats of Black Plum + Black Forest Green.

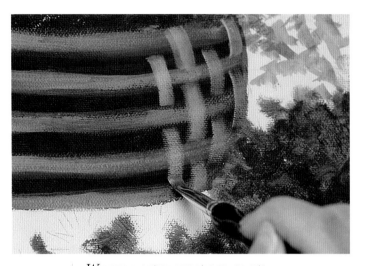

tip When weaving a basket with paint, pretend you are weaving a real basket with wood strips. That helps you figure out the under-and-over weaving pattern.

5 | WEAVE IN THE VERTICAL SLATS

Notice how the vertical basket slats weave in and out of the horizontal bands. Start above the top horizontal band and stroke right over it, stopping just above the next horizontal band. Skip this band, continuing the vertical slat on the other side. Continue in this fashion until you get to the bottom of the basket. For the next vertical slat, paint over the horizontal bands that you skipped over before. Continue alternating your vertical slats in and out of the horizontal bands until you finish the three baskets.

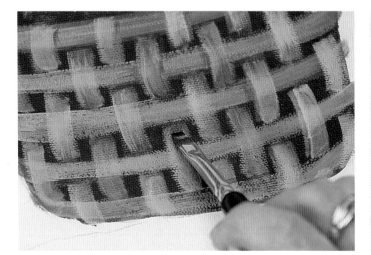

6 | ADD SLAT SHADING

Shade the vertical slats where they go under the horizontal slats with Black Plum + Black Forest Green, using a no. 8 flat.

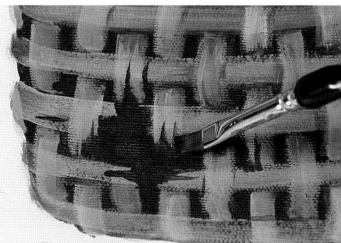

7 | ADD BASKET HOLES

Continuing with the same brush and color mix, make ragged holes in the baskets by painting out some of the slats.

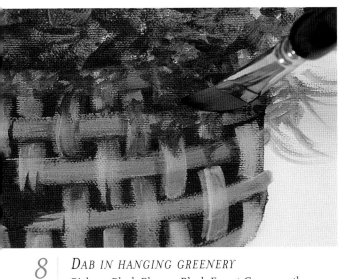

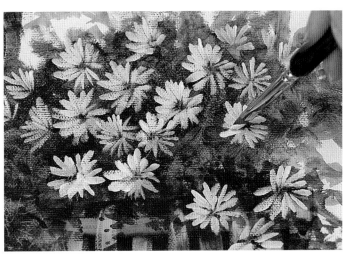

8 | *DAB IN HANGING GREENERY*
Pick up Black Plum + Black Forest Green on the bottom corner of a no. 16 flat and dab in some greenery hanging over the edge of the basket. Work for a loose, irregular look.

9 | *RETRANSFER AND BASE FLOWERS*
Transfer the flowers back in with white graphite paper. Paint the flowers in all three baskets with the chisel edge of a no. 8 flat, using Light Buttermilk. Some of the flowers are only partial flowers. Work for a pleasing composition.

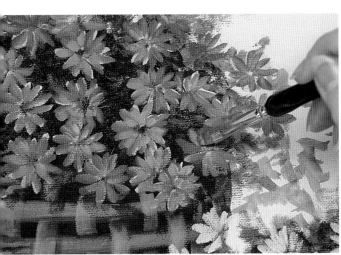

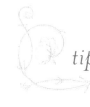

tip The looser these flowers are painted, the prettier they will be. You don't need to follow my pattern lines for the blossoms. Fill your baskets however you wish. Be sure you have some overlapping petals.

10 | *ADD COLOR TO FLOWERS IN TOP BASKET*
Paint the flowers in the top basket by brushing over the Light Buttermilk with Burnt Orange, occasionally picking up a bit of Antique Gold. Work on the chisel edge of a no. 8 flat, stroking loosely from the outside in. Allow some of the Light Buttermilk to show.

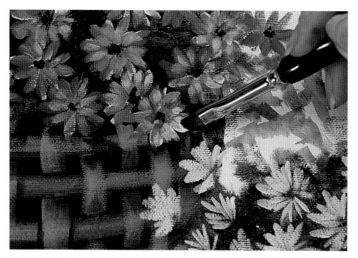

11 PAINT CENTERS AND HIGHLIGHTS

Paint the centers with Black Plum, tapping the paint in with the bottom corner of a no. 8 flat. Add highlights to some of the petals with Lemon Yellow, highlighting mostly on the right sides and, again, working on the chisel edge of the brush.

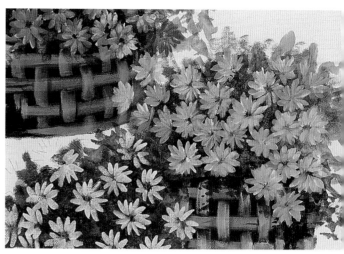

12 PAINT MIDDLE FLOWERS

The middle basket has flowers painted with a brush mix of Antique Gold + Lemon Yellow. Paint these flowers in the same manner as you did those in the first basket (step 10).

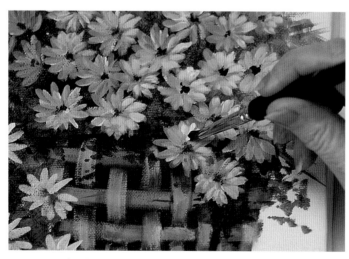

13 PAINT CENTERS AND HIGHLIGHTS

Tap in the flower centers with Black Plum, just as you did in step 11. Overstroke highlights on some petals with Lemon Yellow + Light Buttermilk, varying the color mix. Work for lighter values on the right.

tip When adding highlights, pretend you see a strong light shining on the flowers. Add brighter highlights where the light would fall more intensely.

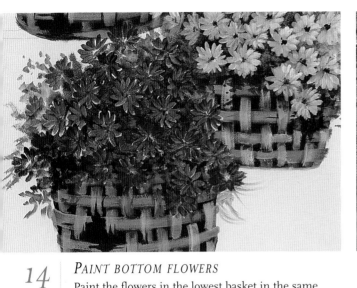

14 | **PAINT BOTTOM FLOWERS**
Paint the flowers in the lowest basket in the same manner as you did the others, using Crimson Tide + Black Plum + Light Buttermilk combined in a variety of brush mixes.

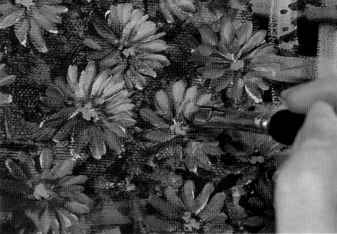

15 | **PAINT CENTERS AND HIGHLIGHTS**
Tap in the flowers' centers as you did before, this time using Hauser Light Green. Highlight the petals with overstroked Light Buttermilk + Lemon Yellow + Crimson Tide in various light mixes.

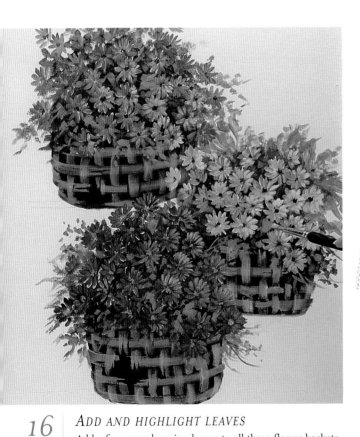

More than anything I must have flowers, always, always.

Claude Monet

16 | **ADD AND HIGHLIGHT LEAVES**
Add a few more hanging leaves to all three flower baskets, using Hauser Light Green + Black Forest Green. Also add a few Hauser Light Green highlights to the leaves among the flowers. Just brush in your strokes lightly with a no. 8 flat, not trying to create actual leaf shapes.

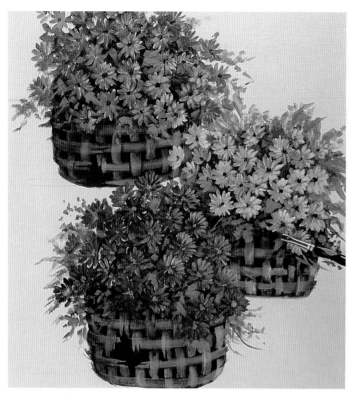

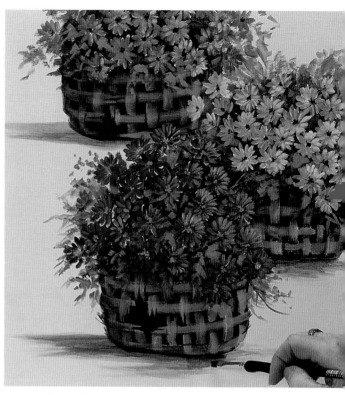

17 | ADD LEAF SHADOWS
Paint some leaf shadows on the baskets with thinned Black Plum corner loaded on a no. 8 flat. For larger shadow areas you can wash in the color with the flat of the brush.

18 | PAINT BASKET SHADOWS
With the same brush, add shadows under the baskets, pulling those shadows out to the left. The paint should be darkest right under the baskets and even into the bottom of the baskets. The paint should be wet so that as the shadows fade away, they will get lighter in value. For the darkest shadows you'll need to apply two or three washes of the shadow color, letting the paint dry between applications. If you feel the shadow lines are too sharp, paint over their edges with a bit of Light Buttermilk.

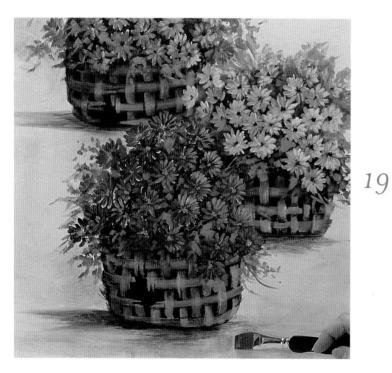

19 | ADD WASHES AND VARNISH
Using a no. 16 flat and very moist paint, stroke in background washes of color around the baskets. Use slip-slap strokes going in many directions, and keep stroking until the paint fades away. Wash on very thin Black Forest Green on the left, thin Lemon Yellow on the upper right, and thin Antique Gold on the lower right. Under the bottom basket add a tint of Crimson Tide. Avoid covering all the Light Buttermilk basecoat.

Let the painting dry completely and then spray with Americana Acrylic Sealer/Finisher.

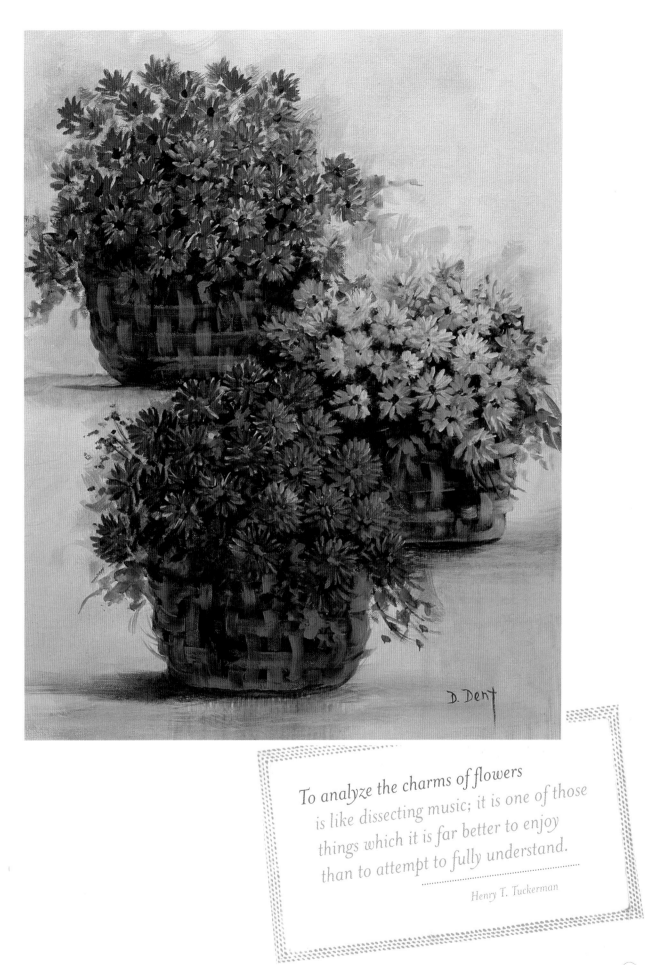

To analyze the charms of flowers
is like dissecting music; it is one of those
things which it is far better to enjoy
than to attempt to fully understand.

Henry T. Tuckerman

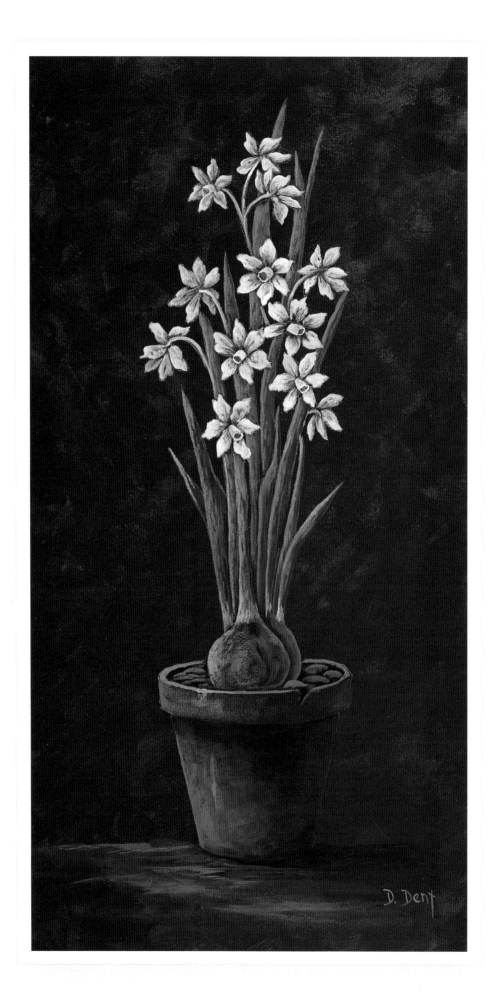

paper-white narcissus

Narcissus is a beautiful, delicate-looking flower that does well indoors, giving your room a little extra cheer when the snow is on the ground. After the flowers finish blooming and the foliage has dried back, you may keep the bulbs to plant outdoors later. The bulb in this painting adds interest to the composition, as does the clay flower pot.

COLORS

DecoArt Americana Acrylics

Antique Gold Black Forest Green Cadmium Red

Hauser Light Green Navy Blue

Payne's Grey Peach Sherbet Russet

Sable Brown Titanium White

Williamsburg Blue

SURFACE
• Stretched canvas, 16" × 8" (41cm × 20cm)

BRUSHES
• no. 2 flat
• no. 4 flat
• no. 6 flat
• no. 8 flat
• no. 16 flat
• no. 0 script liner
• 1-inch (25mm) sponge brush

ADDITIONAL SUPPLIES
• Gesso
• White graphite paper
• Stylus, pen or pencil
• DecoArt Americana Acrylic Sealer/Finisher

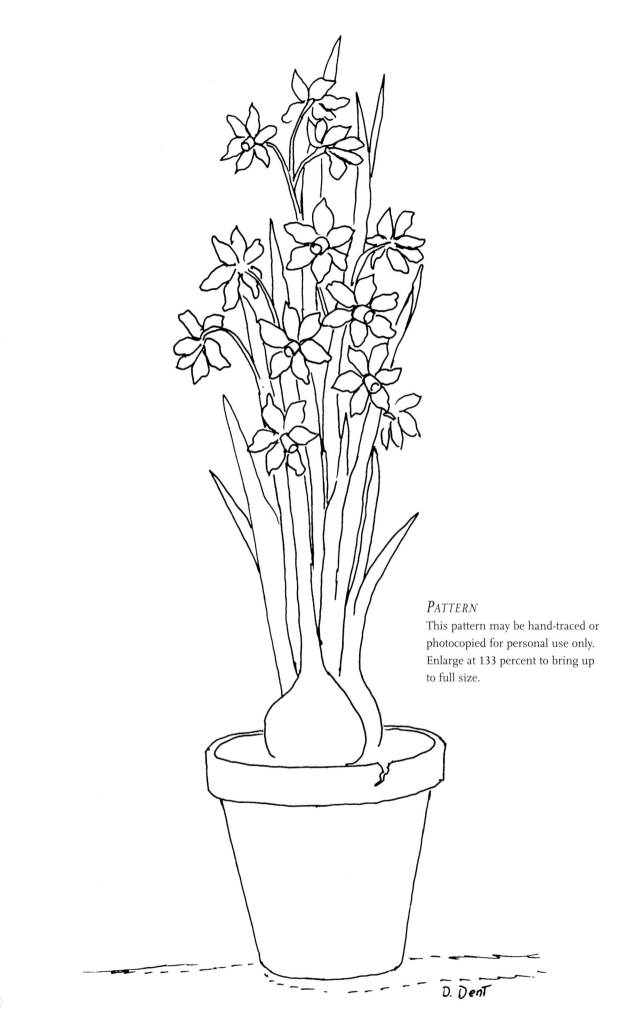

PATTERN
This pattern may be hand-traced or
photocopied for personal use only.
Enlarge at 133 percent to bring up
to full size.

D. Dent

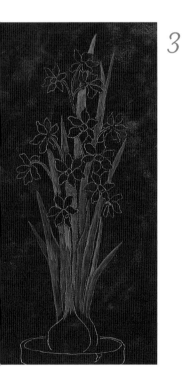

1 SLIP–SLAP BACKGROUND BASING

Prepare your canvas as described on page 14. With a no. 16 flat and Navy Blue, base the background once with slip-slap strokes, letting some of the white canvas show through.

2 REBASE AND TRANSFER PATTERN

Base the background again in the same manner, keeping the paint thinner at the top and heavier at the bottom. Let dry, and then transfer the pattern with white graphite paper.

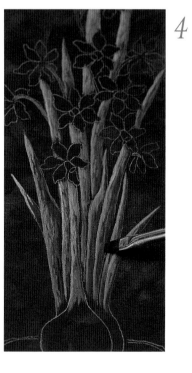

3 BASE LEAVES AND STEMS

Basecoat the leaves and stems with a brush mix of Black Forest Green + Hauser Light Green on a no. 8 flat. Work with the chisel edge of the brush to create a streaky effect that lets a little of the background show through. Leave a separation line on the right of each leaf and stem so they retain their delineation.

4 HIGHLIGHT LEAVES AND STEMS

Highlight the left side of the leaves and the larger stems with Hauser Light Green + a touch of Titanium White, using the no. 8 flat. The most slender stems at the bases of some of the turned-away flowers will be painted later.

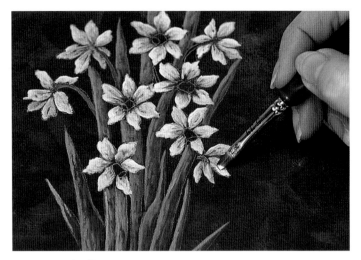

5 | *BASE AND SHADE PETALS*
Base the petals with Titanium White, using a corner-loaded no. 4 flat. Don't worry if a little blue shows through, although you might want to apply a little more white to the tips. If the petals seem too white, apply a little Navy Blue to add a touch more shading.

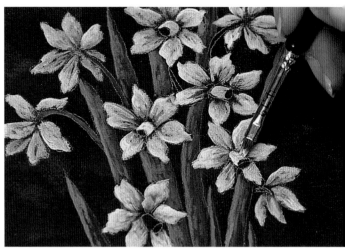

6 | *PAINT TRUMPETS*
Paint the flower trumpets with Titanium White, using the flat surface of a no. 2 flat. Pull the brush in a C-shaped motion.

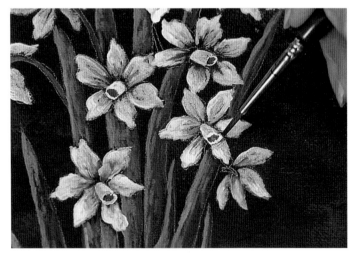

7 | *DETAIL TRUMPETS*
Tap a brush mix of Antique Gold + Cadmium Red in the trumpet centers with a no. 0 script liner. With the same brush, draw a wiggly circle of Titanium White around the outside edges of the trumpets.

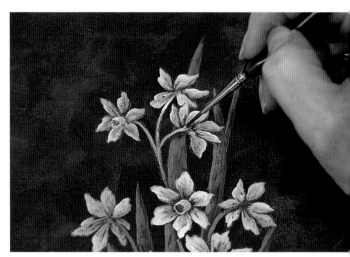

8 | *BASE AND HIGHLIGHT SMALLER STEMS*
Basecoat the remaining stems with Hauser Light Green on a no. 0 script liner. Highlight with Titanium White + Hauser Light Green.

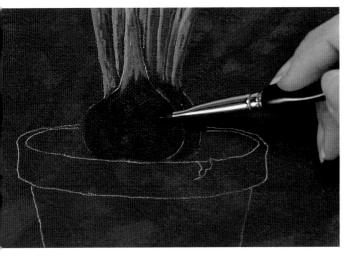

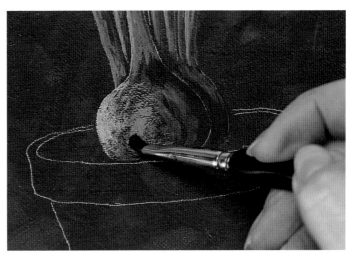

9 | *BASE BULBS*
Base the bulbs in Russet, using a no. 6 flat. Let a bit of Navy Blue show through in places. Follow the contour of the bulbs.

10 | *HIGHLIGHT BULBS*
Highlight the left side of the front bulb with Peach Sherbet + touches of Sable Brown, using the no. 6 flat. Again, follow the bulb's contour. Add a touch of Sable Brown at the top of the back bulb.

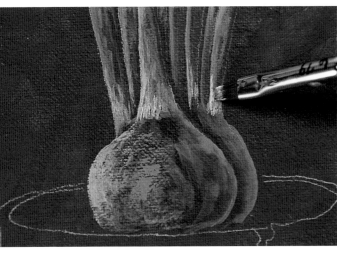

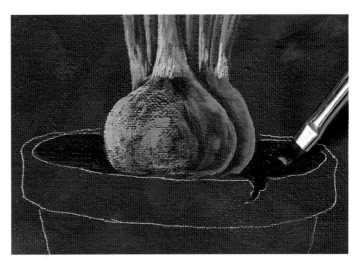

11 | *SHADE BULBS AND PAINT TRANSITION AREA*
Shade the right edge of both bulbs with Williamsburg Blue, using a no. 6 flat. Working with the chisel edge of the same brush, paint vertical streaks of Titanium White where the stems meet the bulbs. Pull a little down into the top of the bulb.

12 | *BASE INSIDE OF POT*
Still working with the no. 6 flat, paint the inside of the pot with Payne's Grey. Be sure to get the color into the crack on the pot rim.

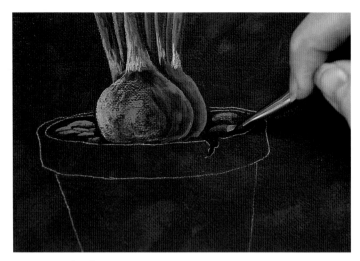

13 | ADD ROCKS

Load Sable Brown on one surface of a no. 6 flat. With the paint on the top of the brush, paint the rocks.

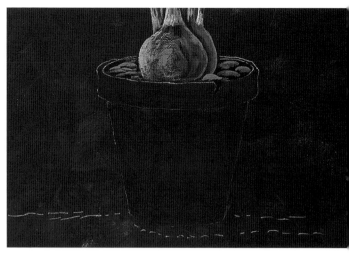

14 | BASE FLOWERPOT

Base the pot in Russet with a no. 8 flat. Leave a bit of Navy Blue under the pot rim.

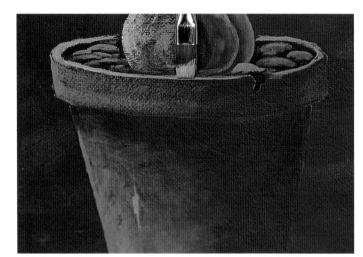

15 | HIGHLIGHT FLOWERPOT

Highlight on the left side of the pot, including the rim, with Sable Brown. Pull the color into the center of the pot, picking up a bit of Russet to help blend. Let the brushstrokes go in different directions. Paint the top edge of the rim with Sable Brown + a bit of Titanium White, using the chisel edge of a no. 8 flat.

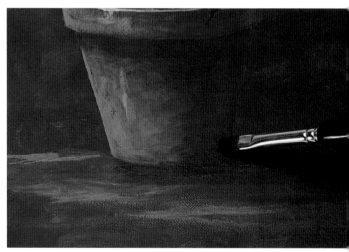

16 | ADD SHADING AND SHADOW

Shade under the rim with Payne's Grey corner loaded on a no. 8 flat. Brush a bit of shading into the pot just right of the center. With the same color and brush, add a shadow under the pot plus a little shading on the pot at the bottom and running up the right side a bit. Add a Sable Brown "swish" on the table.

Let the painting dry completely and then spray with DecoArt Americana Acrylic Sealer/Finisher.

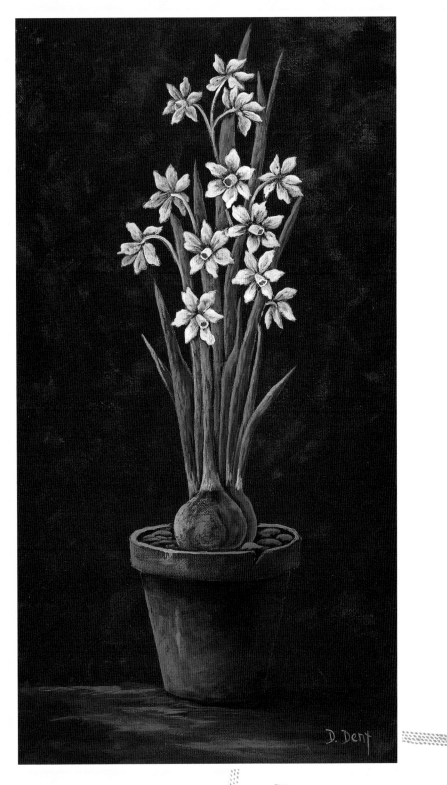

Value flowers in winter
 as special favors.

Claire Davis

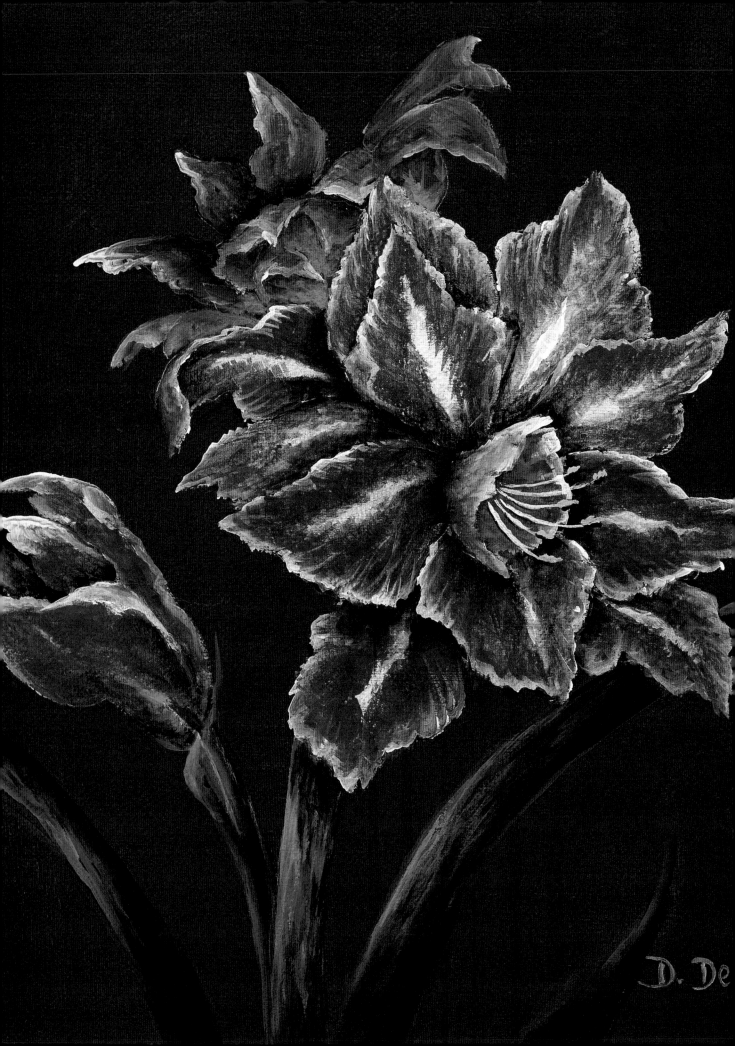

amaryllis

When snow is falling outside and flower gardens are only to be seen in your seed catalogs, painting a beautiful amaryllis will brighten the day. As with all flowers, the proper use of color values creates turned petals and depth. In fact, once you're proficient in getting light and dark values in correct places, you can paint anything.

COLORS

DecoArt Americana Acrylics

Berry Red Black Forest Green

Black Plum Deep Midnight Blue

Golden Straw Hauser Light Green

Titanium White

SURFACE
• Stretched canvas, 10" × 8" (25cm × 20cm)

BRUSHES
• no. 8 flat
• no. 0 script liner
• 1-inch (25mm) sponge brush

ADDITIONAL SUPPLIES
• Gesso
• White graphite paper
• Stylus, pen or pencil
• DecoArt Americana Acrylic Sealer/Finisher

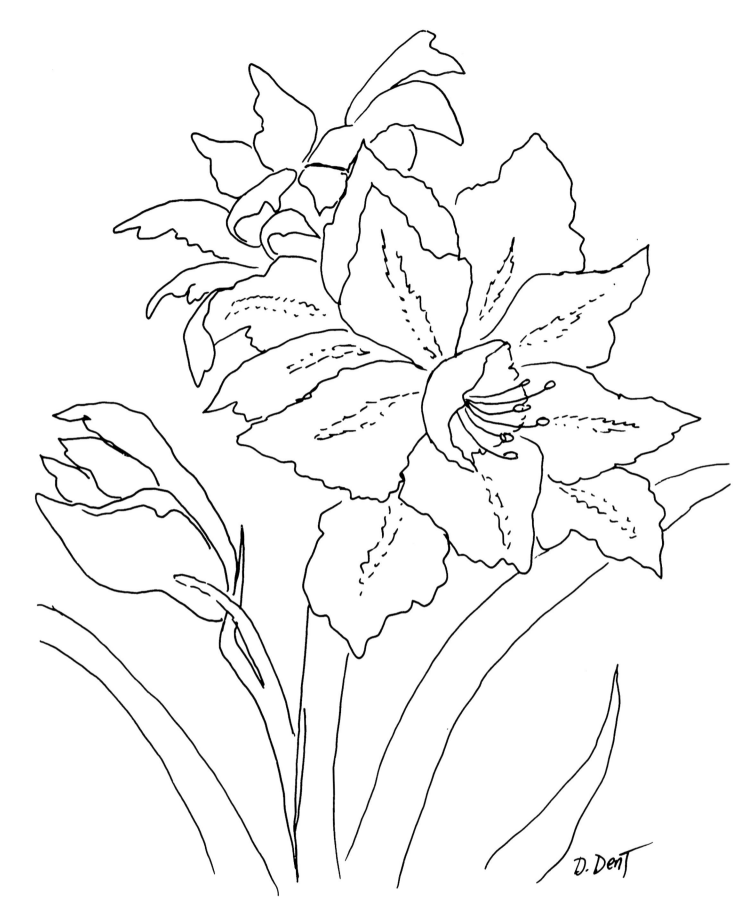

D. Dent

PATTERN
This pattern may be hand-traced or photocopied for personal use only.
Enlarge at 105 percent to bring up to full size.

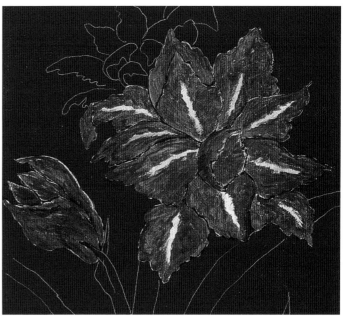

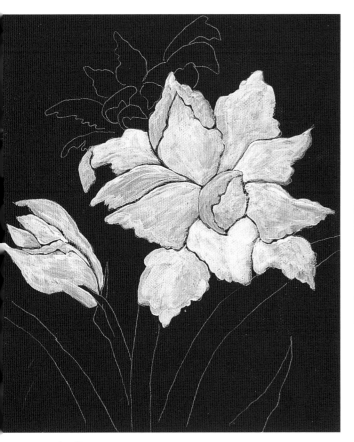

2 | *START APPLYING COLOR TO PETALS*
With a no. 8 flat, paint the petals of the front flower and the bud with Berry Red. Leave a center stripe of the white basecoat on the petals of the front flower. The stripe should be rather ragged on the edges.

1 | *BASE AND TRANSFER*
Prepare the canvas as explained on page 14. Basecoat with two or three coats of Deep Midnight Blue, using a 1-inch (25mm) sponge brush. Transfer the pattern with white graphite paper. Basecoat the petals of the front flower and the bud with one coat of Titanium White, using a no. 8 flat. Leave thin lines of petal separation.

 tip Many amaryllis photos in garden catalogs show a plant with two similar blooms, one pointing straight to the right and another straight to the left. By varying the size, angle and openness of the blooms, I created a more interesting painting.

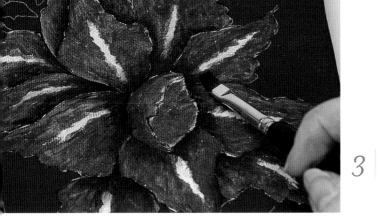

3 | *SHADE PETALS*
With the same brush, shade the base of the petals and between the petals with corner-loaded Black Plum plus enough water to moisten the brush.

121

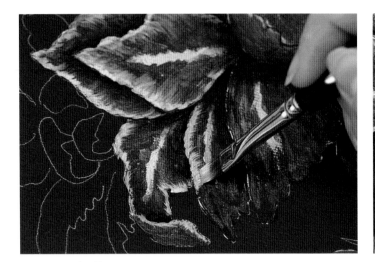

4 | *EDGE PETALS*
Outline the large flower and the bud petal edges with Titanium White. Work with the chisel edge of the no. 8 flat, applying just a bit of slightly moist paint to the petal edge, and then flick down slightly into the petal.

5 | *PAINT INSIDE OF FLOWER CUP*
Corner load a no. 8 flat with Hauser Light Green and work the color into the deepest part of the cupped petals in the middle of the large flower.

The beautiful is as useful as the useful, perhaps more so.

Victor Hugo

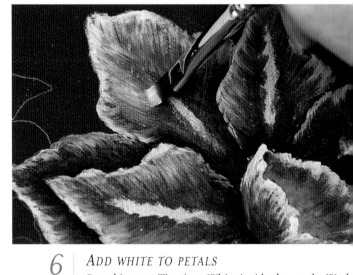

6 | *ADD WHITE TO PETALS*
Pat a bit more Titanium White inside the petals. Work the white more to the outside edges, and then stroke down into the petal to tone down the red a bit.

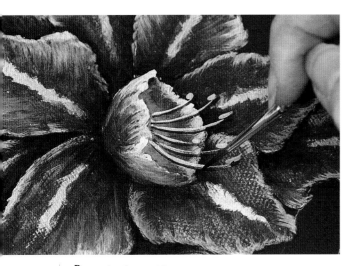

7 PAINT STAMENS

Use a no. 0 script liner and Titanium White to pull out the stamens. Then pull Black Plum beneath the white. Add a bit of Golden Straw to the tips.

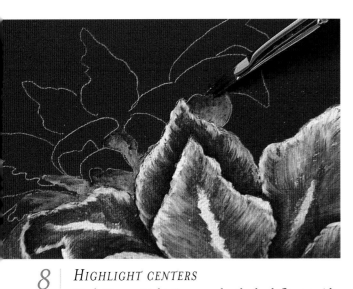

8 HIGHLIGHT CENTERS

Work Hauser Light Green under the back flower with a corner-loaded no. 8 flat. Let some of the background show through. Add a bit of Black Plum for shading underneath the back flower petals. The Black Plum should be thinned so it will overlap the Hauser Light Green a little but not create a hard line.

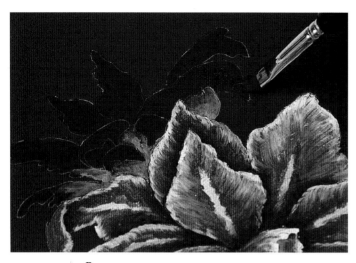

9 | BASE BACK FLOWER

With a no. 8 flat, paint the petals of the back flower in Berry Red. They will be darker than the other flower petals because they do not have the white basecoat.

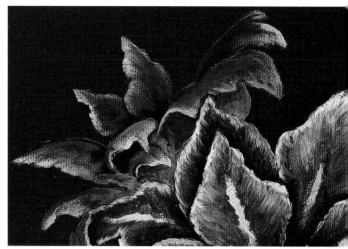

10 | HIGHLIGHT BACK FLOWER

With the chisel edge of a no. 8 flat, highlight the back flower petals with Titanium White + a touch of Berry Red. Stroke slightly in as you did on the larger flower. With the same brush, go back over the tips and outermost edges with Titanium White where additional highlighting is desired. Keep in mind this flower will not be as bright as the one in front, so don't over highlight.

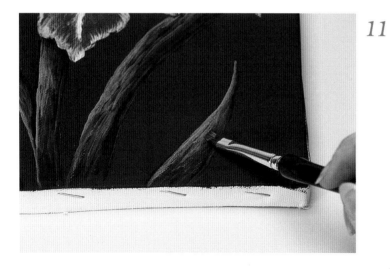

11 | ADD LEAVES AND VARNISH

With the chisel edge of the no. 8 flat, paint the stems and leaves with Black Forest Green + Berry Red. The paint will look black going on. Highlight with Hauser Light Green, working back into the dark leaves with short, choppy strokes made with the chisel edge of the brush. Go for a streaky effect, letting some of the dark leaf color show, especially on the right side. If needed, tidy up around the flowers with Deep Midnight Blue.

Let the painting dry completely and then spray with DecoArt Americana Acrylic Sealer/Finisher.

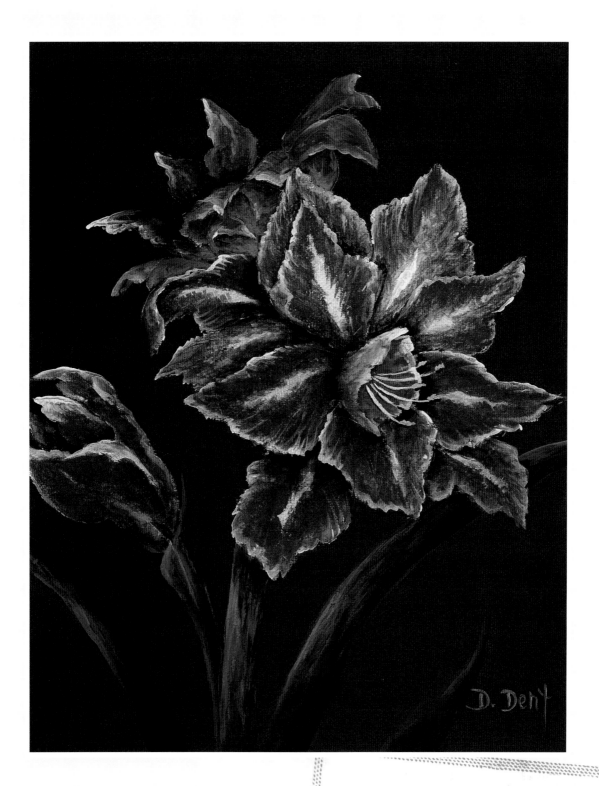

The Amen! of Nature
is always a flower.

Oliver Wendell Holmes

resources

Specific Product Sources

CUSTOM WOOD BY DALLAS
for sewing box
2204 Martha Hulbert Drive
Lapeer, MI 48446-8091

DECOART
*for acrylic paint, Easy Float and
Americana Sealer/Finisher*
P.O. Box 386
Stanford, KY 40484
Phone: 800-367-3047
www.decoart.com

J.W. ETC. QUALITY PRODUCTS
for wood sealer and brush-on varnish
2205 First Street, Suite 103
Simi Valley, CA 93065
www.jwetc.com

MARTIN/F. WEBER CO.
for brushes
USA and International, except Canada
2727 Southampton Road
Philadelphia, PA 19154-1293, USA
Phone: 215-677-5600
www.weberart.com
Canada
26 Beaupre
Mercier, Quebec J6R 2J2, Canada
Phone: 866-484-4411

PESKY BEAR
for lidded basket
5059 Roszyk Hill Road
Machias, NY 14101
Phone/Fax: 716-942-3250
www.peskybear.com

WAYNE'S WOODENWARE, INC.
for wooden tray
102C Fieldcrest Drive
Neenah, WI 54956
Phone: 800-840-1497
www.wayneswoodenware.com

Canadian Retailers

CRAFTS CANADA
2745 29th Street Northeast
Calgary, AL, T1Y 7B5

FOLK ART ENTERPRISES
P.O. Box 1088
Ridgetown, ON, N0P 2C0
Tel: 888-214-0062

MACPHERSON CRAFT WHOLESALE
83 Queen Street East
P.O. Box 1870
St. Mary's, ON, N4X 1C2
Tel: 519-284-1741

MAUREEN MCNAUGHTON ENTERPRISES INC.
Rural Route #2
Belwood, ON, N0B 1J0
Tel: 519-843-5648
Fax: 519-843-6022
E-mail: maureen.mcnaughton.ent.inc
@sympatico.ca
www.maureenmcnaughton.com

MERCURY ART & CRAFT SUPERSHOP
332 Wellington Street
London, ON, N6C 4P7
Tel: 519-434-1636

TOWN & COUNTRY FOLK ART SUPPLIES
93 Green Lane
Thornhill, ON, L3T 6K6
Tel: 905-882-0199

U.K. Retailers

ART EXPRESS
Design House
Sizers Court
Yeadon LS19 6DP
Tel: 0113 250 0077
www.artexpress.co.uk

ATLANTIS ART MATERIALS
146 Brick Lane
London E1 6RU
Tel: 020 7377 8855

CRAFTS WORLD (HEAD OFFICE)
No. 8 North Street, Guildford
Surrey GU1 4AF
Tel: 07000 757070

GREEN & STONE
259 King's Road
London SW3 5EL
Tel: 020 7352 0837
E-mail: greenandstone@enterprise.net

HOBBY CRAFTS (HEAD OFFICE)
River Court
Southern Sector
Bournemouth International Airport
Christchurch
Dorset BH23 6SE
Tel: 0800 272387

HOMECRAFTS DIRECT
P.O. Box 38
Leicester LE1 9BU
Tel: 0116 251 3139

index

books of interest

The best in decorative painting instruction and inspiration is from North Light Books!

This book is the must-have one-stop reference for decorative painters, crafters, home decorators and do-it-yourselfers. It's packed with solutions to every painting challenge, including surface preparation, lettering, borders, faux finishes, strokework techniques and more! You'll also find five fun-to-paint projects designed to instruct, challenge and entertain you—no matter what your skill level.

ISBN 1-58180-062-2, paperback, 256 pages, #31803-K

Create beautiful floral paintings with exquisite detail from petal to stem. From dusty pink roses to dramatic hydrangeas and dainty lilies of the valley, you'll find step-by-step instruction for painting your favorite florals on a variety of surfaces. Each stunning project includes a complete supply list, easy to follow worksheets and patterns.

ISBN 1-58180-461-X, paperback, 48 pages, #32718-K

With Maureen McNaughton as your coach, you can learn to paint an amazing array of fabulous leaves and flowers with skill and precision. She provides start-to-finish instruction with hundreds of detailed photos. *Beautiful Brushstrokes* is packed with a variety of techniques from the most basic stroke to the more challenging, as well as five gorgeous strokework projects.

ISBN 1-58180-381-8, paperback, 128 pages #32396-K

Painting your favorite flowers is easy with Donna Dewberry! Add the beauty and elegance of painted flowers to your projects. This easy-to-use reference provides all the instruction and inspiration you need to successfully paint more than 50 garden flowers and wildflowers in an array of stunning colors. Donna provides complete instruction, beginning with step-by-step photos of her basic one-stroke painting technique.

ISBN 1-58180-484-9, paperback, 144 pages, #32803-K

Add charm to your patio, porch or gazebo with Painted Garden Décor. Designer Patricia Eisenbraun provides step-by-step instructions and full color photos for lovely projects. You'll learn how to decorate a variety of pieces with peaceful scenes of outdoor life, flowers and other garden delights. Special patterns and worksheets ensure success, even if you've never painted before. You'll also find complete materials lists, preparation guidelines and basic brushstroke techniques.

ISBN 1-58180-460-1, paperback, 48 pages, #32717-K

These and other fine North Light titles are available from your local craft retailer, bookstore, online supplier, or by calling 1-800-448-0915.